WHEN
MEMORY
SPEAKS

The Holocaust in Art

Nelly Toll

PRAEGER

Westport, Connecticut
London

Library of Congress Cataloging-in-Publication Data

Toll, Nelly S.
 When memory speaks : the Holocaust in art / Nelly Toll.
 p. cm.
 Includes bibliographical references and index.
 ISBN 0–275–95534–6 (alk. paper)
 1. Holocaust, Jewish (1939–1945), in art. 2. Jewish artists—
Europe—Psychology. 3. World War,—1939–1945—Concentration camps—
Europe. I. Title.
 N6760.T68 1998
 704.9'499'405318—dc21 97–1746

British Library Cataloguing in Publication Data is available.

Library of Congress Catalog Card Number: 97–1746
ISBN: 0–275–95534–6

First published in 1998

Praeger Publishers, 88 Post Road West, Westport, CT 06881
An imprint of Greenwood Publishing Group, Inc.

Printed in the United States of America

The paper used in this book complies with the
Permanent Paper Standard issued by the National
Information Standards Organization (Z39.45–1984).

10 9 8 7 6 5 4 3 2 1

To my husband, my children,
and to Joshua, Danielle, Alexei, Stefan, and Sasha.

In memory of my mother.

"If you to destroy in mankind the belief in immortality, the life of the world, not only love but every living force maintaining would be at once dried up."

—Fyodor Mikhaylovich Dostoyevski

"There is one thing done that stands the brunt of life through its course: it is a quiet conscience."

—Euripides, 485–406 B.C.

CONTENTS

Contents

IV. Living Memorials and Educational Institutions 103

ILLUSTRATIONS

ACKNOWLEDGMENTS

I would like to extend my deep appreciation to the artists, poets, and writers for their permission to use their meaningful contributions in this book.

Many thanks to Shirley Walter for typing the manuscript, Herb Nelson for his photographic expertise, to my editors, and to my friends and family for their support.

INTRODUCTION

The art of the Holocaust depicts the cruelest period in the history of humankind, the Nazis' brutal murder of six million Jews, over one million of them children and teenaged youths. This forbidden art was created in secret hiding places, in ghettos and various camps, under the most horrific conditions, in isolation from the rest of the world. It is beyond one's imagination. And comprehension may never be possible, even if we endlessly search to answer the unanswerable questions in our attempt to grasp the enormity of this crime. Never before in history did any government ever approve and deliberately carry out a scientific program to annihilate a whole race, the destruction even reaching back as far as three to four generations to devour those with any Jewish roots.

In 1942, the Wansee Conference drew up a comprehensive, systematic plan to obliterate all of Jewry in Europe, and it was followed up with carefully thought out persecution. Under the Nazi regime, the Jews were singled out, perhaps as many as five million for total extermination as a "matter of policy." Other victims were also targeted, which included Gypsies, Jehovah's Witnesses, homosexuals, Bolsheviks, political prisoners, anti-Nazi resistance groups, intellectuals, and writers, many of whom were murdered, and others of whom filled the prisons and concentration camps of occupied Europe. Under strictest secrecy, the plan for Jewish destruction was not to be revealed to the public.

We may ask, How does one make art under such desperate circumstances? How does a person respond artistically and intellectually to an existence that revolves totally around the destruction of life? How does a person make the incredible reality credible?

Defying the Nazis, the Holocaust artists risked the most horrifying repercussions if they were caught drawing "camp life," work that they continued to create despite debasement, disease, and starvation. The illustrations they have left the world are a reflection of their spiritual resistance. Perhaps more than death itself, they feared that most of the world would never know what they had endured and that those who were told would not believe it. With an urgent need to recreate their lives in order to leave a sign of their existence, they consciously left us their images so that we would remember. Their paintings became a bridge linking their souls to those of the viewer, to us.

Some of the artists kept notes and memoirs that augmented their art. The victims made use of any material they could find, be it a pencil stub, a burned match, a piece of coal, or scraps of thrown-out paper, and often they traded their meager food rations for art supplies. Using all possible means to conceal their art, the camp inmates often bribed the guards with their last possessions—an extremely dangerous undertaking, which required a lot of planning. In a very real way, they were the embodiment of what Picasso meant when he tried to define art: He claimed that painting is designed as a mediator between us and the world around it and is not necessarily an aesthetic operation, but a way of acquiring power and giving a concrete form to our fears, hopes, and wishes.

The fragmented art that the Holocaust victims have left us testify to the Nazis' ruthlessness. Standing outside the artistic mainstream, this art defies classification. Created under the most inhumane conditions which no one could have ever imagined would exist, it attests to the brutality of the so-called European civilization in the twentieth century.

Despite our lack of chronological and historical data for these artworks, which are still being uncovered in Europe and other parts of the world, our search for more information continues. Fearful of discovery, the camp artists frequently left their works unsigned in order to avoid being traced. Some of these unsigned drawings changed hands in "a prison mail" by being passed on to labor crews, who worked outside of the camps, with the hope that they would "drop" them along the way, "somewhere" in route. Many of these works were found after the war.

Leaving a trace of their presence for posterity, these Holocaust artists extracted from the ghettos and camps an historical truth that is forever preserved in their art. Charged with power and sorrow in depicting their odyssey of horror, the victims produced an art that maintains a remarkable sensitivity.

This cruelest chapter of history is forever intermingled with this art and its integrated memories of a painful past, which has left a permanent stain on European civilization. Whereas traditional art history is based on scholarly inquiry, analysis is based on accumulated research and on stylistic and creative evolution. The art of the Holocaust resists this type of categorization, for it evolved under the most unprecedented circumstances.

In their power and simplicity, this body of art supersedes all aesthetic considerations. The viewer can at most be a sympathetic, though removed, witness to the Shoah; to the vision of smokestacks, to dehumanization and suffering, to the relentless memory of the past. Just as the early Romans, Greeks, and Christians had their own imagery and icons, so did the Holocaust artists with their depictions of extermination centers, barbed wire, smoke, and crematoria, which symbolically became the commemorative marker of the twentieth century. Hamlet's soliloquy, "To be or not to be, that is the question," was set against a background of daily hope of survival, as mothers desperately attempted to save their children.

Primo Levi, the Italian writer who survived his subhuman existence at Auschwitz, stated in *Survival in Auschwitz*, that "daily language is for the description of daily experience but here is an other world, here one would need a language of an other world." "Hier ist Kein Warum"; here there are no "Whys."[1] Israeli author Aharon Appelfeld also survived the Nazis and has stated that he sees no point in asking why he survived, since life in the camps was beyond any reality. For Appelfeld and many other victims, the Holocaust is an episode, a madness, an eclipse that does not belong to the normal flow of time, a volcanic eruption. Though we must be aware of it, it indicates nothing about the rest of life. Similarly, while filming *Shoah*, Claude Lanzmanns' leitmotif of "Not Understanding" was the rule he imposed on himself. It obliterated all questions, echoing past the blue sky and the background surrounding his camera.

By creating his own art, without being part of the "outside," the Holocaust artist, true to his inner values, expressed his own form of existential resistance and displayed an enormous

fight for survival. Holocaust art stands alone. It is quite unlike the medieval imaginary landscape of horror; or even Goya's frightening scenes of the civilian massacres during the Napoleonic wars; or the atrocities of war so vividly portrayed in Picasso's "Guernica." Indeed, Holocaust art is a reality that clouds all reason.

The Germans tried to cover up the full magnitude of the genocide, when with the Allied armies approaching in 1944, they evacuated the outlying concentration camp victims in their infamous last Death March. The ethical and moral implications are only now beginning to be understood more fully. Through art the reader and the viewer can glimpse at another universe, unique in its evils, which hopefully will not then be only a memory. This book includes art created by victims who did not survive, in the camps, ghettos, and other hiding places. It also covers the works of artists who did survive the Holocaust and were left to reflect on their experiences. Expressions by those who were affected by the Shoah, reacted to it, but did not personally experience the European tragedy, are also represented in this book.

In the opinion of the post–World War II abstractionist, Rico Le Brun, no serious artist can neglect the Holocaust. In his works, painter Leonard Baskin sees the genocide as a curdling reality of the least of human endeavors.

Each painting in this book tells a story of its own. Unfortunately, many of these stories cannot be documented, having perished with their creators.

I

Art in the Holocaust

In the Camps

Evoking the enduring desperation and abuse, the camp victims' art of dissolution and dismemberment is only a microcosm of their reality. Only those who were there could feel the impact of that inferno. Trying to survive under the most unbearable conditions, even when they had become but emaciated shadows of themselves, the Holocaust artists continued to create, leaving traces of their existence before departing from life.

Six concentration camps took on a unique assignment. They became killing centers with gas chambers and crematorials. The largest one, Auschwitz, was administered by Rudolph Hoess (Auschwitz-Birkanau), who substituted Zyklon B (used earlier) for the less efficient carbon monoxide.

Since the Germans operated under the strictest rules of secrecy, the half-starved victims in the cargo trains who arrived from various parts of Europe, supposedly for "Resettlement" in the East, were driven by civilian conductors in the local region involved. The prisoners did not discover their true fate until they entered the extermination camp, surrounded by electrical wired fences and armed guards. Men and women guards exercised the cruelest behavior (at Ravensburg, Germany) and dedicated themselves to the most sadistic behavior.

Gela Seksztejn

Gela Seksztejn was born in 1907 and died in Treblinka in 1942. In her writings, found after her death, she attempted to document for future generations the suffering of the Jews in the Warsaw ghetto. She urged the survivors not to forget and to tell the world about the genocide of the Jews.

The uprising in the Warsaw ghetto did not take place until more than 300,000 Jews had been deported. By 1943, only 50,000 remained, starving victims who had committed no crime but were scheduled for extermination. Life in the ghet-

When Memory Speaks

to was no longer measured in terms of days and hours; there was no hope of survival. Babies were stuffed into suitcases and smuggled out, whereas the older people and women with children hid in sewers and bunkers. Most of them perished.

Cultural activities not only served to hinder the Nazi plan, but also played an important role in the Jews' active resistance in Warsaw. One of the most important examples of Warsaw's ghettos was the historical documentation by Emmanuel Ringelblum, an historian who was uniquely qualified to understand the value of documenting events in the ghetto. He carefully collected and hid as many documents as he could. Many of the documents were found after the war hidden in large metal milk cans.

Gela Seksztejn, painter and writer. Warsaw Ghetto. Born in 1907, she died in Treblinka in 1942. Courtesy of Nelly Toll.

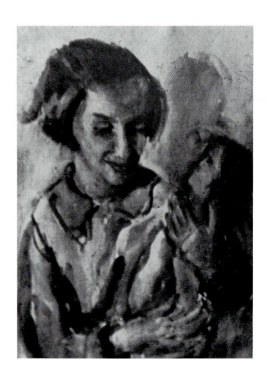
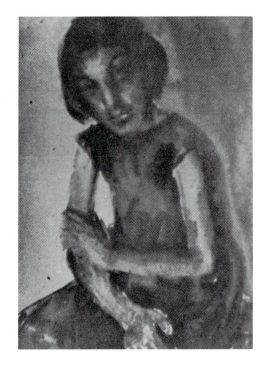

Bertolan Gondor

Bertolan Gondor drew his cartoons during March, April, and May of 1944, when the Germans took over the Hungarian labor camp and the deportation to Auschwitz began. Gondor's style is reminiscent of that of Czech cartoonist Joseph Lada, who illustrated *The Adventures of a Good Soldier*, though Gondor's is more refined. Both artists depict the Nazis' brutality. Gondor was forced to camouflage his messages, as he did when he sent postcards to his wife, knowing that the artwork had to pass through Nazi censors. Filled with quiet despair, Gondor avoided self-pity and was oblivious to any personal consequences. His artworks tell us of his personal courage; like a patchwork, they warn others of the dangers. He, too, perished.

Bertolan Gondor,
Postcard, March 11, 1944
through May 24, 1944.
Courtesy of Nelly Toll.

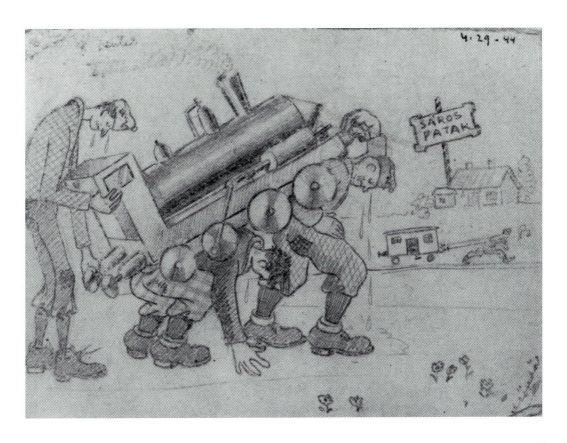

Bertolan Gondor, Postcard, March 11, 1944 through
May 24, 1944. Courtesy of Nelly Toll.

Translation: My love, a greeting, a kiss, a snapshot from
your Bui.

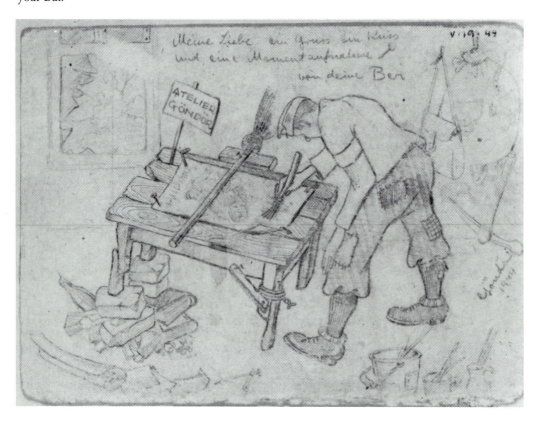

Bertolan Gondor,
Postcard, March 11, 1944
through May 24, 1944.
Courtesy of Nelly Toll.

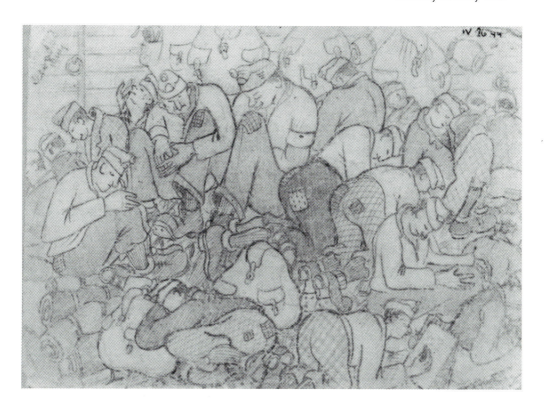

Bertolan Gondor, Postcard, March 11, 1944
through May 24, 1944. Courtesy of Nelly Toll.

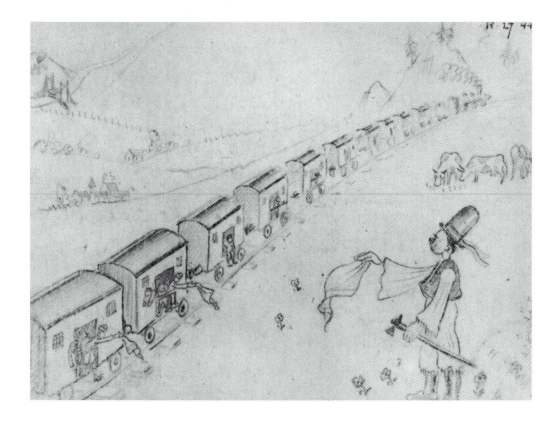

Bertolan Gondor, Postcard, March 11, 1944 through May 24, 1944.
Courtesy of Nelly Toll.

Translation: My dear little heart,
Although my feet are surely getting shorter from wear, my love for you can
only grow. My dear, take care of yourself, don't worry about me. I'm well,
and, as you can see, my sense of humor hasn't disappeared. I'm thinking of
you continuously, my beloved. I miss the Bans, too. —Bard

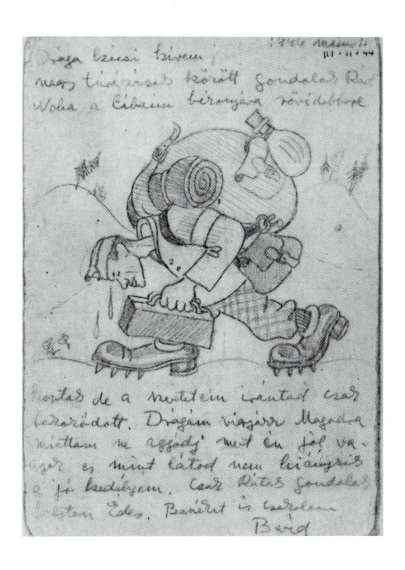

* * *

The young and the most able were selected for slave labor in coal mines, quarries, rubber factories, and other areas. In I. G. Farben in Auschwitz III, as well as other camps, the eleven-hour shifts and the meagerest of food portions only temporarily allowed the men and women to stay alive. Once they became too weak from starvation and from their horrifically long working conditions, and were no longer able to work, they were gassed and were replaced by Jewish victims half dead from thirst and starvation who arrived in the constant flow of sealed and guarded cattletrain loads. Most of the time the trains were driven by a civilian who lived in a local region. The Jewish transports from all parts of Europe kept entering the camp, but the world remained silent; no one protested.

Prominent psychiatrist Robert J. Lifton, author of *Nazi Doctors* (1988) has spent much of his professional life studying the doctors of the Holocaust. He found that many of the German doctors resorted to the cruelest and most complicated, inhuman experiments and were the key agents in the Holocaust.

Buchenwald.
Courtesy of Nelly Toll.

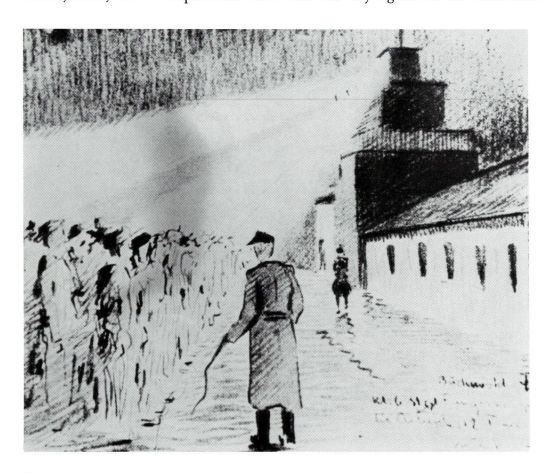

Particularly crucial to Hitler and his party was the moral and scientific legitimacy provided for this racial and biological genocide. Doctors had an enormous part in the killing; it was they who selected who would live to work, who would die in the gas chambers, and who would serve their experiments.

The well-constructed gas chambers and crematoria, designed by the most sophisticated engineers, were often employed by privately owned German factories and reaped enormous profits. Supervised by the Germans, the camp guards were usually citizens of the occupied country. Many of them, as noted earlier, were murderers and cruel criminals who were dedicated to their "work," gladly and sadistically going beyond their duties.

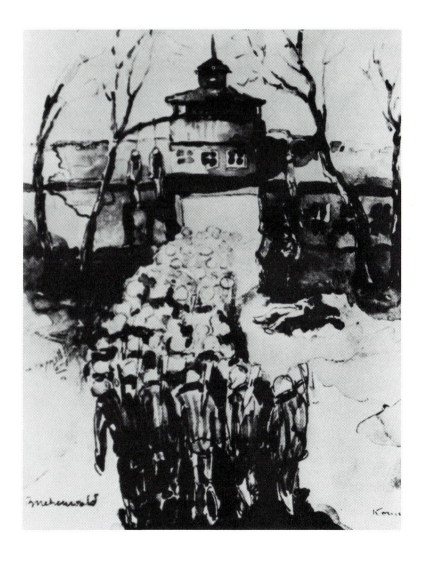

Buchenwald. Courtesy of Nelly Toll.

When Memory Speaks

Even under the harshest of camp conditions, many victims refused to surrender their humanity, as the stronger tried to help the weaker. Although no words are adequate for giving us a full measure of this inhumanity, Nellie Sachs, a Nobel Prize-winner, André Schwarz-Bart, Jerzy Kosinski, Yahuda Bauer, a Nobel Prize-winner, Elie Wiesel, a Nobel Prize-winner, Viktor Frankl, Primo Levi, and numerous other writers and prominent historians have attempted to "transform their vocabulary" in describing these experiences.

Dr. Burton Wasserman of Rowan University has sadly reflected on the inhumanity of man in confronting the *Shoah*: "The Holocaust must surely stand as the most atrocious crime committed against human life and civilized values during the entire history of the 20th century; the record of genocide and despicable collateral events that were collectively carried out by the Nazi regime in its attempt to implement final solution to the Jewish problem."[1]

Buchenwald. Courtesy of Nelly Toll.

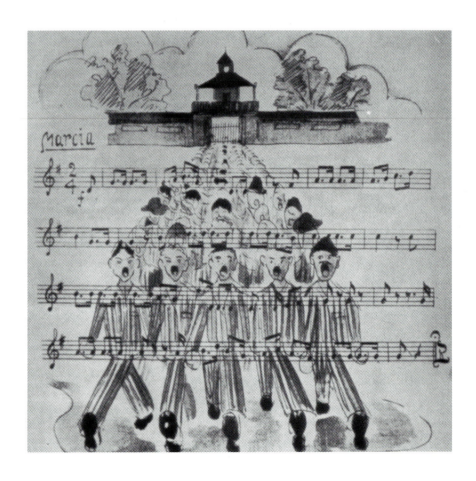

It is incredible that Hitler, armed only with his personal determination, was able to mobilize European civilization under the guise of religion, law, and science to follow and solidify his plan to build centers for killing human beings. The destruction of the Jews, the major goal of the National Socialist party, proceeded according to a systematically outlined process. With all the fervor of a religious person who seeks to validate his commitment to God through a certain behavior (good deeds), so did the committed SS men and guards show their dedication to Hitler in murdering the Jews.

Menu in Bergen-Belsen, 1944. By Irsai. The contents of the cauldron, listed in Hungarian are: kolraby 8%, carrots 5%, meat (magnified) 1%, mussels 5%, potatoes (magnified) 3%, pumpkin 8%, turnips 20%, and water 50%. Courtesy of Nelly Toll.

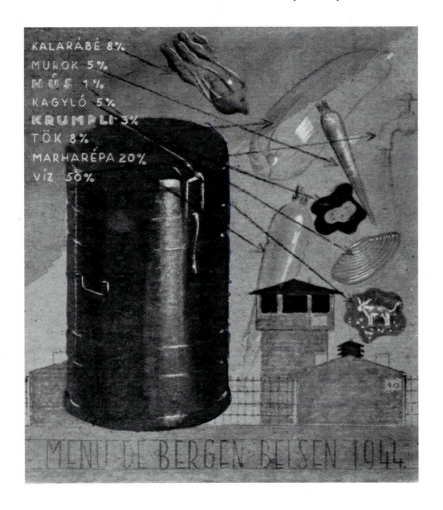

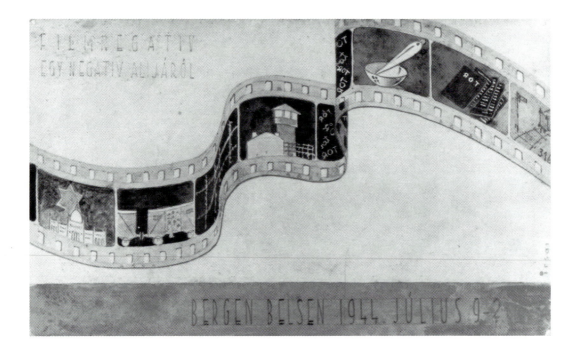

Bergen-Belsen, July 9, 1944. By Irsai. The reel of film shows Parliament with the Star of David, symboliz-
ing the Jewish Council; cattle cars with people crammed inside; barbed wire; barracks; a guard tower;
"tor," the Hungarian word for "Lots," referring to those chosen for the special transport to Switzerland; a
bowl and spoon (both empty); more "tor" lists; the last car of a train, with the caption 316, the number of
people who were freed in Bergen-Belsen. An inmate exchanged cigarettes for two drawings by a camp
artist named Irsai. These were carried to freedom; the fate of the artist is unknown. Courtesy of Nelly
Toll.

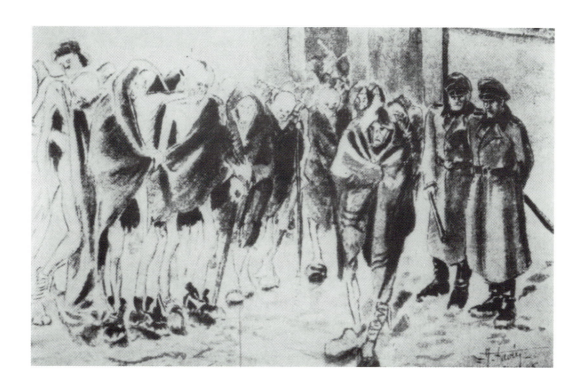

Buchenwald. Courtesy of Nelly Toll.

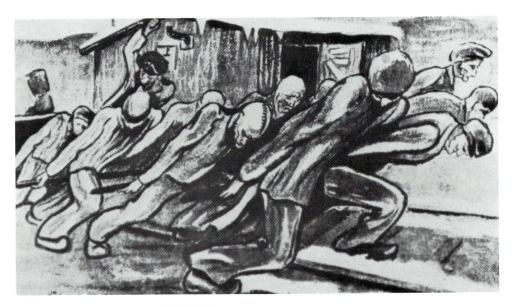

Camp unknown. Courtesy of Nelly Toll.

Buchenwald. Courtesy of Nelly Toll.

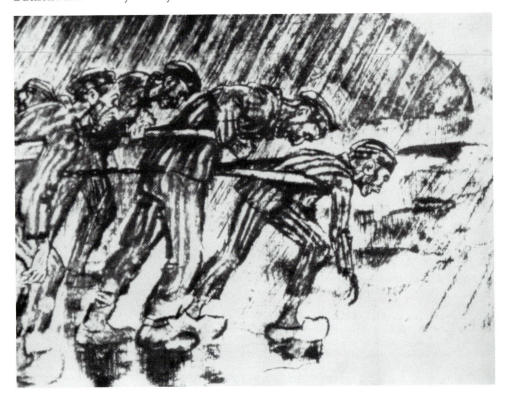

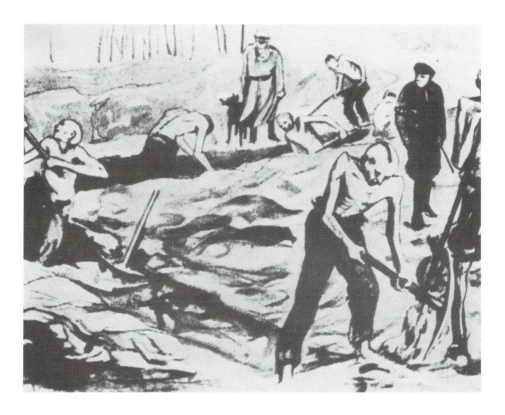

Buchenwald. Courtesy of Nelly Toll.

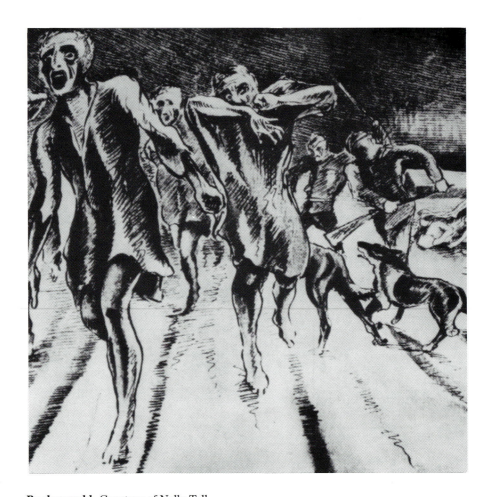

Buchenwald. Courtesy of Nelly Toll.

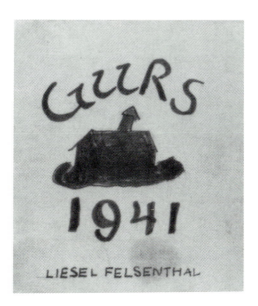

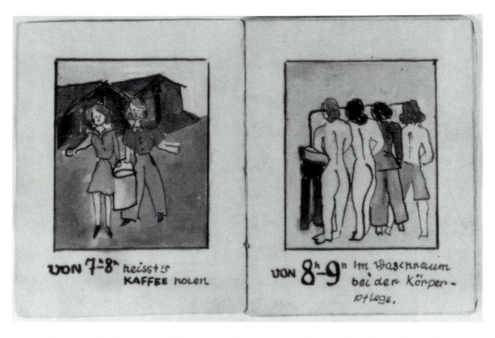

Liesel Felsenthal. "Gurs 1941." Illustrated diary of a murdered girl in Camp Gurs. Watercolor in a nonbound book format 2 ½" × 3." "It's Time to Get Coffee" and "In the Bathroom." Courtesy of Nelly Toll.

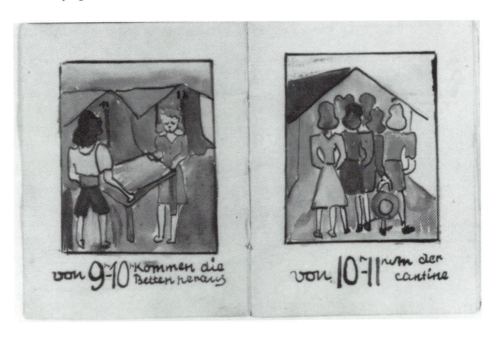

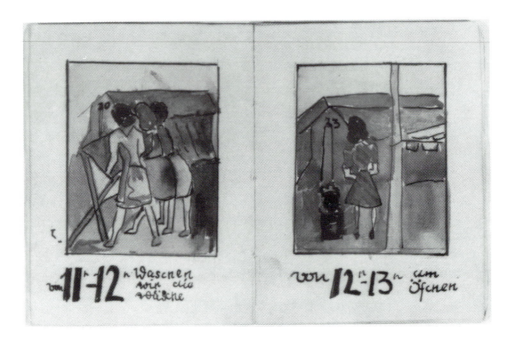

Liesel Felsenthal. "The Beds Are Aired"; "At the Canteen"; "We Wash the Laundry"; and "At the Stove." Camp Gurs, France. Courtesy of Nelly Toll.

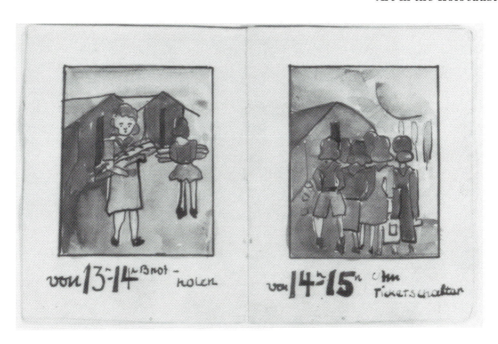

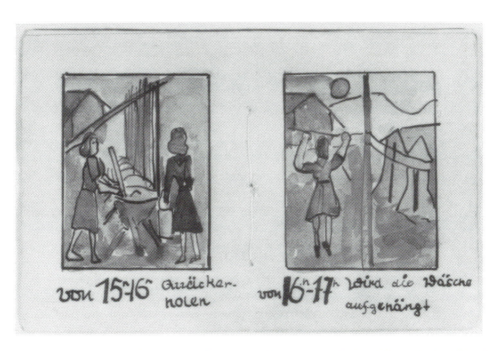

Liesel Felsenthal. "Fetching the Bread"; "At the Ticket Counter"; "We Pick Up the Food"; and "Hanging Up the Wash." Camp Gurs, France. Courtesy of Nelly Toll.

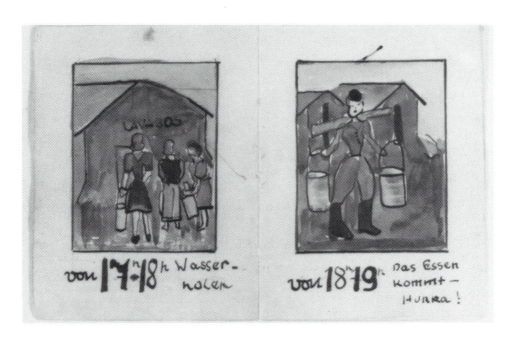

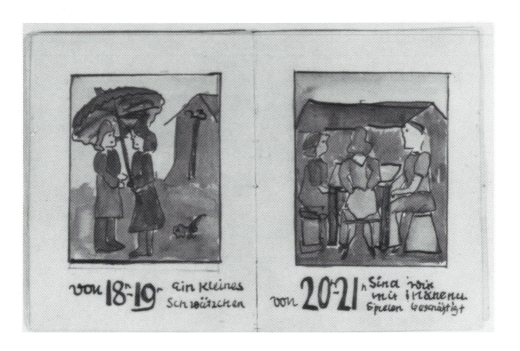

Liesel Felsenthal. "Fetching Water"; "Dinner Is Ready. Hurrah!"; "A Little Chat"; "We're Busy Playing Card Games with the Men." Camp Gurs, France. Courtesy of Nelly Toll.

II | Historical Perspective

Control of the Arts

In the 1920s, prior to Adolf Hitler's rise to power, Germany's poets, musicians, architects, and artists constituted a vital aesthetic force. One of Germany's most innovative artistic contributions in this period was the Bauhaus movement, which embraced not only architecture but also a whole range of the visual arts. This movement was recognized throughout Europe and became a major international influence. In addition, the Bauhaus City School, of Dessau, with its celebrated faculty, attracted such well-known artists as Wassily Kandinsky, Paul Klee, and Weimar Marc.

As early as the late 1920s and early 1930s, the Nazi oppression had already begun to be extended to Jewish artists. The progressive German painters who were involved in expressionism, abstractionism, and Dadaism (founded in Zurich, Switzerland, in 1916, "Dada" being a French kindergarten word meaning "hobbyhorse") focused on a state of mind rather than on a particular style and rebelled against Nazi values. Among Dadaism's more prominent exponents were George Grosz in Berlin, Kurt Schwitters in Hanover, and Max Ernst in Cologne; these outspoken figures expressed deep concern about Hitler's growing popularity.

Even before the Nazis came to power, however, artists throughout Europe reacted to the growing political turmoil in Germany, symbolically depicting their fears of what was to come. Painter Otto Dix of the Neue Sachlichkeit (the School of the New Objectivity), who was influenced by nineteenth-century romanticism, juxtaposed the German Gothic tradition with images of expressionism. His detailed canvases filled with machinelike monsters symbolized the oncoming of evil forces. Another artist of this period, Max Beckmann, a leading exponent of expressionism, though not politically involved nevertheless strongly responded to the Nazi threat through his brush strokes. His distorted and emaciated figures served as a grim premonition of the living corpses that would soon populate the concentration camps.

Another artist, the well-known German expressionist Emile Nolde, reflected on the impending crisis with passionate intensity through his massive canvases on which slashes of violent color created chilly landscapes and fantasies of the future

destruction. Marc Chagall, a prominent Jewish painter, frequently juxtaposed his Parisian existence with his childhood memories of the Jewish persecution in Russia. More than most, he realized that dangerous forces were gaining popularity, and he depicted his fears in his art.

The sculptor Jacques Lipchitz is most noted for his massive sculpture "Prometheus Struggling with the Vulture," which symbolized Hope and the Victory of Light over Darkness. He too became a prophet of the Nazi brutality, in his "Bull and Candor." Fortunately, he went into hiding with his wife in the hills of southern France, and with the help of non-Jewish friends was able to escape to the United States.

Painter George Grosz, who changed his name from Gross to Grosz in order to have a less German-sounding name, castigated the Germans for their militarism and became actively involved in anti-Nazi propaganda. One of his earliest antiwar caricatures, "Germany, a Winter's Tale," paints a kaleidoscopic portrait of Berlin, combining the menacing expression of the Prussian generals, officers, and greedy burghers with broken objects and superimposed figures probably inspired by Heinrich Heine's poem. Grosz's powerful portfolio of antiwar drawings depicts the Nazis as instruments of evil and includes savage caricatures of Hitler in the 1930s. Using theater as his medium for expressing his opposition to the Nazis, he was noted for his antiwar stage design for "The Adventures of Good Soldier Schwiek." He finally escaped to the United States with his wife shortly before all doors would close to the Jews of Europe.

Oscar Kokoschka, an expressionist from Vienna, known for his morbid portraits, gave vent to his deeply anti-Nazi feelings just before 1934 when he fled to London. The same year, the Nazis confiscated his work, proclaiming it "degenerate." Another noted painter, Max Ernst, a leading German surrealist, was publicly humiliated, forbidden to show his work in Germany, and also termed "a degenerate artist."

Also attacked were the works of the leading modern architects such as Bruno Taut, Peter Behrens, Ludwig Mies van der Rohe, Walter Gropius, Heinrich Tessenow, and Erich Mendelsohn.

Mainly through political propaganda Hitler gained control over the arts, encouraging violent antisemitism and ridiculing expressionism, impressionism, cubism, surrealism, futurism, and abstract art, all of which the Nazi party condemned as degenerate art. As the chief culprits, Hitler singled out the Jews and Bolsheviks for their "modern, vulgar, and foreign

influences" on the arts. More importantly, they were blamed for Germany's economic deterioration.

Historical Perspective

Hitler's Rise to Power

Even as a young man, Hitler hated Jews. He especially disliked the artists with innovative ideas, who lived and worked near him in the Bohemian Schwab district. He branded the modern painters as "cultural Bolsheviks" influenced by the evil of the Jews.

Upon his return from prison, where he had been sent after the November Putsch and where he had written *Mein Kampf,* Hitler dedicated himself to politics and discovered his singular ability to fire up the dissatisfied German masses. Weighed down by anxiety, poverty, and unemployment, the people were filled with resentment against the countries that through the Treaty of Versailles had so thoroughly humiliated Germany.

Hitler's party promised change and improved economic conditions so that by 1931, the National Socialist party had become the strongest and the most important political organization in Germany. Adolph Hitler, its most powerful figure, came to power on January 31, 1933.

According to Hitler's recollections of his childhood, which he describes with morbid self-pity in *Mein Kampf,* he had a poor relationship with his father and fought with him constantly; his life was motivated by secretiveness, continuous schemes, and lies.[1] A poor student in the secondary school in Linz, he was not promoted to the next grade. It has been speculated that this may be one reason why he decided to become a painter. Another possibility may have been his desire to acquire power through art, for at the end of the nineteenth century, a painter or a poet was considered a "kind of a king," a Renaissance figure, and someone who like a "royal artist" could in time dominate society.[2]

With money borrowed from his widowed mother to support himself, Hitler continued to paint, despite his rejection from the Academy of Fine Arts. He continuously made the rounds of the furniture dealers and picture frame manufacturers, who occasionally would buy copies of his Vienna postcards to fill their empty frames. (In recent years several of these images have been exhibited in European art galleries.) Years later, his interests in neoclassical art and nineteenth-century paintings and architecture increased, and Hitler

became a fervent believer that German architecture could become the Third Reich's most powerful expression of absolute political power. These musings led to his grandiose dreams of redesigning Munich, Linz, Berlin, and Nuremburg. Also an admirer of virulent antisemitic composer Richard Wagner and his wife Cosima, Hitler utilized Wagner's hate of the Jews and intoxicated Germany with racial intolerance, taking advantage of the centuries-old European antisemitism. Inspired by antisemitic writers such as Max Nordam (the first artist to use the word "degenerate" in art in connection with modern art), Julius Langbehn, M. Nisser, and Houston Stewart Chamberlain (who promoted racial hate), Hitler was drawn to their ideology.

In the early 1900s modern European art and literature was in search of truth (rather than beauty in the traditional sense) and expressions of human suffering (a major theme in painting and sculpture), creating antagonism among provincial German people who did not want to see this aspect of their reality. Their anger assumed a stronger tone once Hitler appeared on the scene. A manifesto protesting the modernists was signed by 134 artists, who rallied against the Jews blaming them, together with the Bolsheviks, for espousing Expressionism.

Intolerance of foreign influences in the arts continued to increase in Germany. When, in 1919, the Berlin National Gallery opened the Brücke (Bridge) and the Blaue Reiter (Blue Rider) art exhibitions, followed by exhibitions of Picasso and Braque, popular opposition to these alien un-German modernists grew stronger, despite the opposition of *Der Stürm*, a liberal and influential publication. Hitler continued to encourage these attacks. Now the German people's love for orderliness became coupled with a desire to foster Aryan heroic art and nationalistic German ideology. Clearly, Germany was waiting for someone to lead them, to create new order out of the economic and artistic chaos, and Adolf Hitler was ready to be that someone.

When, in 1937, a major "degenerate art" exhibition opened in Munich, the exhibition catalog did not resort to subtleties. George Grosz's drawings, for example, were accompanied by text alluding to the sexual corruption and moral degeneration of his work. Nor were others spared.

The Munich show marked the beginning of Joseph Goebbels' concentrated effort to eradicate modern art in Germany, with Hitler's propagandist declaring that the artists who did not share the Nazi ideology and patriotism for Germany would be dealt with appropriately. The nationalistic propa-

ganda increasingly linked expressionism with the so-called Jewish-Bolshevik conspiracy, and the Nazi government's attacks moved into high gear. As a result of Goebbels' campaign, over twenty painters were murdered and 16,000 works of art were confiscated. Some works were sold abroad to help finance Hitler's museum in Linz, whereas others were burned or appropriated by the minister of aviation, Hermann Goering. On Hitler's personal orders, art critic Einstazstab Rosenberg conducted a search for valuable Jewish-owned furniture and art objects in occupied Europe. Once the treasures were shipped from Paris to Germany, Rosenberg cataloged them, and many of them became part of Hitler's and Goering's private collections.

The government proceeded rapidly in is "purification" of the arts, confiscating what was branded as "Jewish vermin art" and "decadent" non-Jewish modern art. Under Goebbels' direction, posters were hung all over Berlin denouncing the Jews and espousing the Aryan ideal. Counting on the public's emotional appeal, the attractively displayed placards urged the people's support for the flourishing Hitler Jugend (Hitler Youth Organization) and its female counterpart, the Bund Deutscher Mädchen (League of German Girls). Pro-Nazi murals and paintings showing images of the Führer heroically slaying Jews and Bolsheviks and portraits of helmeted storm troopers marching through the streets with clenched fists, as well as Hitler's slogans, became the major decor of banks, post offices, and other public buildings.

Following Hitler's dictum that brutality and physical force were to be glorified, Hans Schweitzer-Mjölnir, a prominent Nazi artist, produced exaggerated depictions of the German storm troopers' Herculean strength and with other state artists continued to focus on the Führer's heroism and glory. In contrast to the works encouraged by the government, modern art, the art of moral decay, and "decadent expressionism" posed a threat to the Nazis.

In the new order, Goebbels, the man who dictated the future cultural approach of the Reich, decreed that the artist's role had to change. Disguising the true role of the Cultural Chamber, he claimed that it offered the artist greater freedom than ever before. In the new Germany, where the tradition of the "Volk" now reigned, the artist was no longer to be interested in himself as a private person but rather would become a public figure serving the Reich and its people.

The new role of political educator promoted only "racially pure" and "politically dependable" artists who valued German

nationalism. Admitted to various Cultural Chambers, many artists and writers began to reach the highest positions within various cultural fields, as they united to solve the "Jewish problem," even before the Nazi party did. The Reich Cultural Chambers' members, which numbered about 45,000, were offered many privileges; particularly benefiting were those who strongly supported the Reich. At the beginning of Hitler's rule, they were exempt from military service, a privilege that was not even granted to scientists who were held in the highest esteem.

Terms like *Degenerate Art with Jewish-Bolshevik Influences* had been used before 1933 in describing almost every artistic endeavor that was considered modern—even the work of the non-Jewish Kathe Kollwitz and Ernst Barlach, both of whom were internationally recognized artists. Through the cinema and posters, Goebbels utilized visuals in his cultural campaign, intoxicating the masses with promises. Well aware that anyone could turn off the radio which broadcast the Führer's daily speeches in offices, government buildings, and schools, Goebbels knew that no one could miss the well-displayed posters containing Hitler's slogans as posted by the Reich Chamber of Culture, founded in September 1939. In this way, Goebbels successfully promoted the Nazis' propaganda art.

The German Jugendbewegung (the youth movement) and the nationalistic Wandervogel (the Wandering Birds, a poetic version of the Boy Scouts) grew immensely popular because of their patriotic emphasis. Formed in 1901 by Karl Fischler, it quickly spread throughout the entire country. The young people's stress on loyalty to their nation, love of nature, and the pure Aryan German Volk (folkdom—"oneness") became a central unifying factor in their lives and art, and was often expressed through hymns while hiking in the countryside. Hitler's forces promoted the concept of the purely Aryan Volk for its youth and for all the generations.

The National Socialist Society for German Culture (1928–1929), which became the League for Defense of German Culture, sought to end the "corruption of the modernists." Headed by Alfred Rosenberg, the organization sought to inform the German people about the relationship between race and artistic values and to become "the moral foundation of a heroic and victorious art of the future" by eliminating all Jewish and Bolshevik influences.

On May 10, 1933, the notorious burning of the books took place, thereby ruthlessly crushing any "artistic" opposition. The works of Sigmund Freud, Karl Marx, and Stefan Zweig,

Serious oppression of the Jews began with the Crusades. Hordes of nobles, knights, monks, and peasants who set off to free the Holy Land, now Israel (to the Muslim, Palestine), began their bloody work with the Jews. Offering the choice of baptism or death, the Crusaders slaughtered the Jewish population.

In his youth, Martin Luther had been a champion of the Jews, but when he failed to win them to Protestantism, he raged at them, renewing all the old charges—the Jews were poisoners, ritual murderers, usurers, parasites, and devils. He called for the burning of their synagogues, the seizure of their books, and their expulsion from Germany. Centuries later, Hitler would find it helpful to circulate Luther's anti-Jewish writings in mass editions.

Under Otto Von Bismarck, Prussia's prime minister in the late nineteenth century, the educated classes turned away from rationalism and liberalism, embarrassing the conservative stance of French author Arthur De Gobineau and the Englishman Houston Stewart Chamberlain who used various strategies to symbolize the myth of racial superiority. While De Gobineau maintained that the Jews were a "Mongrel race," Chamberlain wrote that the Jewish race was bastardized and that their existence was a crime against the laws of life. Both men attracted large audiences in Germany for praising the Aryan race and advocating antisemitism. Through the power of Nazi propaganda, the masses were told that only the Führer could stop the Jews, who together with the Bolsheviks had to be uprooted as speedily as possible. Cooperation was needed in order to accomplish this goal and to assure Germany's survival from foreign influences.

Nazi party rallies, which stressed sports, promises of the economic future, full employment, and victory for Germany, made skillful use of Hitler's forceful personality. His notorious speeches at the Berlin Olympic Games in 1936 and his appearance with Leni Riefenstahl, the attractive propagandist filmmaker, noted for her documentaries *Triumph of the Will* and *Olympia*, both of which glorified Hitler, drew tremendous crowds. As a result, Riefenstahl's name is forever yoked to the Nazi criminals.

On November 9, 1938, on Kristallnacht (the Night of Broken Glass), an angry mob of citizens, orchestrated by the Nazis, carried out fifteen hours of madness; 7,000 Jewish-owned stores, 1,000 synagogues, and 76 other stores were demolished. Following that vicious event, the government piously announced the decision that the Jews would pay an atonement for having caused the damage. And pay they did: millions of

dollars worth. Following these fresh atrocities, new restrictions were issued against the Jews. In all spheres of life (including the cultural), Jews were now to be discriminated against. Chagall's symbolic "White Crucifixion," describing Jewish suffering before 1939, is one of the many artistic responses to Kristallnacht. Although hopeless, surrounded by hate, Jewish and non-Jewish artists alike—Jack Lipschitz, Ben Shahn, Pablo Picasso, Leonard Baskin, and many others—portrayed their anger through art. Nonetheless, various artistic communities continued to admire Hitler's patriotic programs, and many signed documents pledging their loyalty to the Führer and applauding the new regime.

Cheering masses greeted Hitler's arrival in Vienna in 1938. Most were unaware, however, that many writers, painters, and intellectuals like Stefan Zweig, Carl Zuckmayer, and Sigmund Freud had already fled the country. Despairing, painter Egon Friedell threw himself out of a window. Orchestras were cleansed of their "Jewish elements," but other members of the musical world such as Richard Strauss, Wilhelm Furtwangler, Eugen Jochum, Elisabeth Schwarzkopf, and other well-known artists lent their support to the Nazi party.

Hitler's anti-intellectual propaganda attracted many intellectuals to whom modern art now stood for foreign decadence, Jewishness, homosexuality, Bolshevism, and capitalism. Exploring Nazi "patriotism," German realistic painters, working in the nineteenth-century tradition, resented the modernists mostly because those artists were receiving world attention and were getting high prices in the international art markets. These realistic painters believed that their time had at last arrived, and so they jumped at the opportunity to glorify German Art, "the Volk," and the art of "everyday" people.

In 1937, the Ministry for Education and Science published a pamphlet in which Dr. Reinhold Krause, a leading educator of the Nazi regime, claimed that Dadaism, futurism, cubism, and other artistic "isms," like a parasitical plant, had grown on German soil, and must now be completely destroyed, together with the Jews of Europe. The Degenerate Art Commission headed by Franz Hofmann proceeded to implement the sale of the "undesirable art" to European collectors. Upon Hitler's approval based on his realization that great financial gains were to be had, international dealers were apprised of the availability of modern art for sale. The Swiss Galorie Fischer organized an auction in Lucerne and the transactions took place, but remarkably, many important works of art remained in Hitler's own possession.

Unlike modern artists, supporters of the Nazi regime interested in medieval Germanic scenes (who painted in the neoclassical style) now focused on strong Aryan men and athletic Volk, with the background of idealized nature. These works enjoyed great popularity in Germany in the Nazi years. Hitler's admirers, such as the artist Elke Eber, glorified the Aryan ideal, propagating the images of tall blond women with "healthy body" and wide hips, and the "future sacred mothers," preordained to be the bearers of the Führer's children. Eber's women were reminiscent of those from the "stud farms," the Lebensborn, the "Fountain of Life Centers" designed for those German women who volunteered (and were selected) for the important members of the SS in order to create a "master race" through selective genetic breeding. Set up in luxurious resorts, these maternity homes conveniently provided for the Gestapo were created by the Nazis' leading racial fanatic, SS Chief Heinrich Himmler. Believing in their "special mission," the isolated, handsome German women deliberately impregnated by the high-ranking SS officers remained in the secret houses ready to bear children for the future victorious Reich. After Germany's defeat, the women made every attempt to remain anonymous.

Theresienstadt

Theresienstadt, the ghetto–concentration camp located at the junction of the rivers Ohre and Elbe about 60 kilometers north of Prague, would become part of the moral conscience of the silent world. Experiencing many wars, the town dates back to the end of the eighteenth century. To protect the town from Prussian wars, the Austrian Empire which occupied Bohemia (now Czechoslovakia) decided to build a fortress that would prevent the Prussian army from penetrating the country.

In October 1780, Emperor Joseph II constructed a fortress that he named after his mother, Empress Maria Theresa (thus the name Terezin, as called by the Czechs). It was comprised of the Main Fortress and the Small Fortress, an outpost of a fortified area between the New and Old River. Terezin was proclaimed a royal free town in 1782, and although the number of its inhabitants grew slowly, at the beginning of the 1930s the population surpassed the 1,000 mark. During World War I, large prisoner-of-war camps were established there. Creation of an independent Czechoslovakia in 1918 accelerated Theresienstadt's transition to a purely Czech town.

Located between the Czech and German ethnic regions, the town did not develop economically despite its abundant cultural and social life.

Five months after the Nazi invasion, restrictions were imposed on the Jewish population in Terezin and on political prisoners, and a year later a police prison of the Prague Gestapo was established in the Small Fortress. By November 1941, the whole town population was evacuated, and Theresienstadt was transformed into a ghetto–concentration camp for Jews.

Despite its deplorable conditions, Theresienstadt was a "privileged" camp, and unlike the horrific camps like Dachau and Auschwitz, it became a Nazi showplace, trying to give a false illusion of freedom with its veneer of cleaned-up streets. The hungry, depressed-looking men, women, and children were strictly ordered not to utter a word of complaint (lest there be repercussions) to the visitors of the International Red Cross, who came to examine the prisoners' living conditions on June 23, 1944. The Nazis guided the official Red Cross members through the camp-ghetto's freshly painted exteriors, which, as the Commission visitors later reported, seemed to be "satisfactory." One naturally wonders how much the Commission really wanted to know and to see.

Camp Theresienstadt's population consisted of "privileged" families with children, important personalities, such as the highly regarded Rabbi Leo Baeck, well-known musicians, artists, writers, and the "michlings"—those of mixed Christian-Jewish background.

In the beginning, only a few Jewish victims guessed the strictly kept secret that Theresienstadt was only a temporary stop on the way to the extermination camps. The Nazis' mass deportation programs, camouflaged as labor transports that constantly shifted prisoners from place to place, used various deceptive means to conceal that reality. Their movements were always shrouded in secrecy.

Living conditions in Theresienstadt, as depicted through art, reached amazing proportions. Supplied with art materials, Jewish and a few non-Jewish professional artists working in the Nazi-designated drafting room produced blueprints and paintings for SS headquarters. At the same time, they were secretly creating their own documentary art. Because many of the pictures were preserved, today we can see the camp's desperate living conditions with their images of hundreds of victims suffering from hunger, disease, fear, and hopelessness. Dead corpses cover many sheets of paper; they remain the

silent witnesses of the murdered victims.

Drawings and paintings by such professional artists as Bedrich Fritta, Leo Haas, Otto Ungar, Karel Fleischmann, Petre Kien, Moritz Muller, Charlotte Buresova, and Hilda Zadikova exemplify their talent and skill even under horrendous conditions. Despite strict warnings from the Nazis, who prohibited such depictions, they exposed life in the Theresienstadt camp with all its pain and tragedy. Upon discovery of the forbidden drawings, the artists and their families would be taken to the dungeon-prison known for its torture—to the Small Fortress from which virtually no one ever returned alive.

And yet the artists, with a sense of spiritual resistance, continued to create. Some of the drawings were buried in secret places; others were preserved by friends of the artists, whom the Nazis did not have enough time to kill. Numerous artworks were successfully smuggled out of the ghetto–camp shortly after they were created and were recovered after the Russian liberation. These images constitute a remarkable, unique collection attesting to the victims' strength; even death could not erase their existence.

The saddest phenomenon of the Theresienstadt concentration camp was the life of the children, who saw everything, absorbed much pain, but only partially understood their circumstances. Unlike the adults, they were unable to intellectualize the cruelty of the Germans. Uprooted from their parents, children's wants, and play, they lived in dismal isolation. The children's favorite occupation was drawing, and their teachers knew that they had to keep them busy in order to give them at least an illusion of a few happy moments, before the next "transport" would whisk them away. Surreptitiously, they provided them with scraps of paper, pencils, and pastels. Using art and poetry, the children poured their feelings of fear and loneliness onto paper. Realistically depicted guards, funerals, the departing transports, and the shooting of the German soldiers were reflected in the art of the boys. Little girls often focused on images of their past childhood years in freedom, filled with the joy of the sun, with children playing, families gathering at meal time, gardens, and meadows full of flowers and butterflies. Drawn on small sheets of paper, often collaged from scraps, boys and girls made sketches of their friends, produced still life, wrote poetry, and often finished with heart-breaking poems. Characterized by the liberal use of color and freedom of style, these artworks give us a glimpse of the children's tragic years, often filled with the hope of staying alive. They have left us many images of their sorrow.

Teachers and nurses dedicated themselves to giving secret lessons to those children who stood watch in order not to be found out. They would hear of executions, living in dread of the much feared transportations to the extermination camp, always worrying when their turn would come, when they would have to leave with the next transport to the "East." The children did not take their pictures with them. After liberation, their poems and colorful drawings were compiled into a book titled *I Never Saw Another Butterfly*. The original poems and drawings are housed in the Prague Museum and the Terezin Museum. Of the 15,000 children who entered Theresienstadt, only 100 survived.

Janusz Korczak

Dr. Janusz Korczak was born in Warsaw in 1878. He was a pediatrician and the director of an orphanage and was murdered with the children in his care. He once wrote:

A child is a hundred masks, and plays a hundred roles of a skilled actor; different one for the mother, different one for the father, grandmother, or grandfather, different one for the stern or sympathetic teacher, different one in the kitchen or among peers, for the rich one and the poor, and different one for everyday and for holiday. Naive and cunning, well-behaved and self-willed, he knows how to conceal and hide and play a role well, as well as how to deceive and take advantage of us. Regarding instincts, he lacks only one—or rather he possesses it, splintered as it may be like. That is why an adult is so frequently like a child, and a child like an adult. Finally, all other differences boil down to the fact that he is not a wage earner and being so dependent, he is forced to give away to our will.[3]

Once it became obvious that the Germans were exterminating the Jews, Korczak was offered various hiding places by his many Christian friends but he rejected them all. He would not abandon his orphaned children. A dedicated educator, he devoted his life to improving the children's welfare. He fought for their rights and respect until the very end when he and his orphans were taken to the extermination camp.

On August 10, 1942, at the Umschlagplatz near the railway station in the center of Warsaw, a group of 200 orphaned children in neat rows of four made their last journey in a quiet way. Dr. Korczak walked with a child in each hand; the eyes of the children looked for his support and courage.

On the long road from the orphanage to the train station, Dr. Korczak told the children that they were going on a "school outing." He prepared them carefully, knowing that when the group reached its destination, they would be loaded together into the trains to Treblinka. As his last legacy, two days before he and his children were murdered in Treblinka, Korczak wrote that he did not exist to be loved and admired but to love and act, and that it was his obligation to be concerned about man and the world.

Korczak has been honored around the world; today his name is used for various scholarships and awards.

Historical Perspective

Israel Bernbaum. "Janusz Korczak and his children on the way to the train." Bernbaum, who survived the war in Siberia, was an illustrator and painter, and author of *My Brother's Keeper*. He died in 1995. Reprinted courtesy of © Israel Bernbaum Memorial Shoah Fund of the Holocaust Resource Center, Jewish Federation of Greater Clifton-Passaic New Jersey.

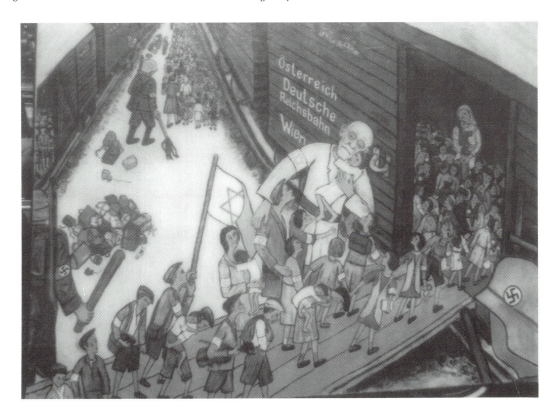

The Kindertransport*

We learn from the history of the Holocaust that 1.5 million children lost their lives, but few people are aware that 10,000 children were saved by being brought to England through the intervention of the British Government. This became known as the Kindertransport.

After the horrors of Kristallnacht on November 9, 1938 (the night of broken glass), when more than 267 synagogues were destroyed and several hundred Jews were killed or taken to concentration camps, only the British Parliament raised questions of concern for the situation of the Jews in Germany. Under the auspicies of the CBF (Central British Fund)—founded by Anglo-Jewish communal leaders following Hitler's appointment as Chancellor of Germany—the Inter-aid Committee for German Children was founded. After lengthy debates in the House of Commons, it was decided to admit an undefined number of children providing they would be sponsored by responsible organizations or individuals and a bond was posted for them. They could not be a burden to the country. The age limit was set at 17 with the provision that they came unaccompanied by parents.

A caring group of women, including several non-Jewish and Quakers, immediately took off for Berlin and Vienna and other large cities where they confronted Nazi officials, like Adolf Eichmann, face to face to obtain permission to transport groups of children out of the country.

Most of the children ("Kinder" as they call themselves to this day), traveled by train to Holland, where Dutch people cared for them until their departure by ferry to England. Others left from German ports on passenger ships. In this manner 10,000 children were saved from Germany as well as Austria and Czechoslovakia. Young men and women were recruited as escorts.

In Britain a consolidated effort was made to find housing for the young refugees. Many families, Jewish and Gentile, opened their homes. Hostels and schools accepted groups of children and neglected castles were readied to accommodate boys and girls.

It was a hard time of adjustment for the children. The winter of 1938/39 was particularly severe and the youngsters suffered from the damp and cold in the unheated houses. There

*This section was submitted by Anne L. Fox. Used by permission of Anne L. Fox.

are many stories of discomforts, exploitation and even abuse, but above all of homesickness and longing for their loved ones.

The Kindertransports were suspended with the outbreak of war. On September 3, 1939, the Government decided to evacuate all children living in large cities which were likely to be bombed by the enemy. Most of the refugee children became uprooted a second time. Families in small towns in the Midlands were asked to accept evacuees for minimal compensation.

When the war was finally won, the "Kinder" hoped to be reunited with their families. For many of them it was not to be. Six million had died in the Holocaust. Those families who had managed to gain entrance to other countries, now wanted their children to join them. For quite a few it meant uprooting again. England had become their home and English was their language now. They did not want to leave.

While the majority of "Kinder" settled in England, many came to America while a large number emigrated to Israel, others are scattered all over the world.

In 1989 a reunion was arranged for in London which 1,000 "Kinder" attended. After 50 years they met former friends and schoolmates, those who had been in the same hostel or evacuated to the same town.

A year later the K.T.A. (Kindertransport Association) was organized in New York. There was a get-together in the Catskills in 1991 and 300 attended. The organization has grown to over 500 with several regional chapters. It is the aim of the "Kinder," not only to make charitable contributions to children in need all over the world, but to tell their story publicly to schools and organizations.

Anne L. Fox came to England with the Kindertransport from Berlin, Germany, in December 1938. She is the author of *My Heart in a Suitcase.*

III

Artists' Retrospectives: Responses

IT COULD BE SAID that the impact of the Holocaust has been felt in all areas of our culture. The mass killings hover in our collective conscience as the realization of the basest possibilities, the inconceivable torture and starvation serving as a reminder of man's capability for inhumanity. Artists have contributed to the documentation of the Holocaust and its psychological aftermath by expressing their anguish, horror, sadness, disbelief, and even hope. Some portray a post *Shoah* mourning—not only for the dead, but for the sensibility of the human race. Others memorialize family members lost, reminding us that for each story we hear, there are many more we have not heard.

On the pages that follow, artists respond to the Holocaust. They represent a wide range of artistic expression—from abstraction to realism, from paintings to poems. They also bring diverse perspectives. The artists include Jews and non-Jews, as well as survivors of the Holocaust and their children.

Larry Rivers

Larry Rivers, an internationally renowned painter who depicted Primo Levi—author of *Survival in Auschwitz: The Nazi Assault on Humanity*—with a great deal of sensitivity, is an influential American artist. Born in New York City, he studied with Hans Hoffmann and was one of the first artists to turn away from abstract expressionism. In the early 1960s, Rivers adopted pop art in his use of commercial images and products, but he remained expressionistic in his tone. Rivers chose this passage as an example of life at camp according to Primo Levi's writing on the camp:

The greater part of the prisoners who did not understand German . . . died during the first ten to fifteen days after arrival: at first glance, from hunger, cold, fatigue and disease; but after a more attentive examination, due to insufficient information. If they had been able to communicate with their more experienced companions, they would have been able to orient themselves better. . . . Except for cases of pathological

When Memory Speaks incapacity, one can and must communicate. Absence of signals is itself a signal, but an ambiguous one, and ambiguity generates anxiety and suspicion. To say that it is impossible to communicate is false.

—Primo Levi, from *The Drowned and the Saved*

Larry Rivers. "Primo Levi: Survivor" (1987). Courtesy of Larry Rivers.

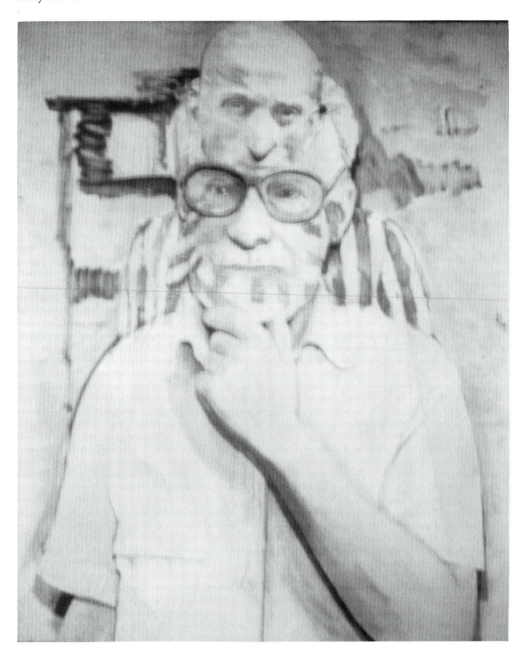

Larry Rivers. "Primo Levi Periodic Table" (1987).
Courtesy of Larry Rivers.

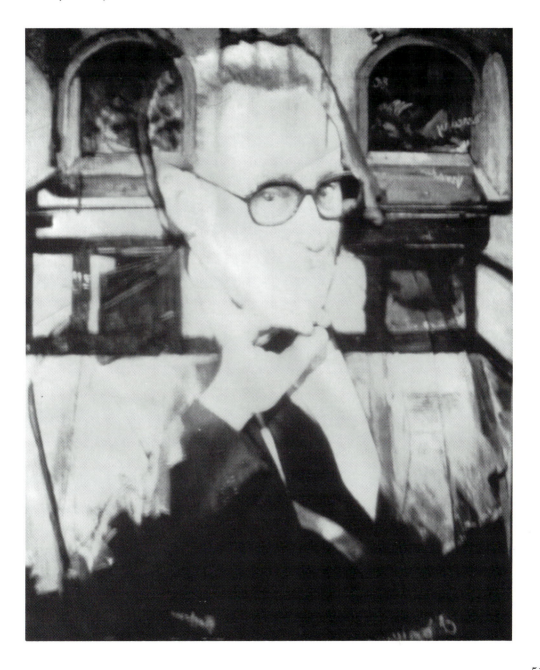

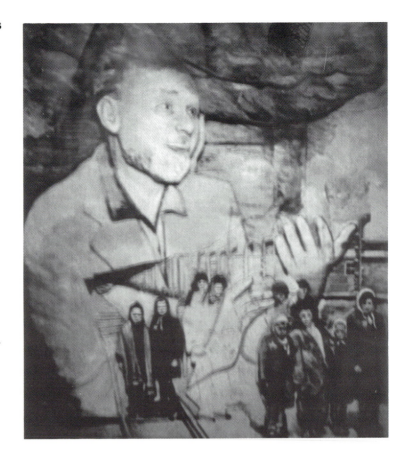

Larry Rivers. "Portrait of
Primo Levi: Witness"
(1988). Courtesy of Larry
Rivers.

N. Mieses

In paying homage to motherhood, Sarah Lewis (*Voice*,
April 28, 1993) stated that she focused on the survival of a
particular mother and her eight-year-old daughter in hiding.
Both were sheltered by a Christian family in Lwow, Poland.

Imagine being restrained in three small rooms for more than
eight thousand seven hundred hours! Amidst the many
expressions of remembering the Holocaust period, we as a
society have not paid enough tribute to the Women who ful-
filled the task of Motherhood.

In the midst of daily fear, and threat, this young courageous
Mother tried to create a sense of normalcy for her child. In the
midst of all the danger, this mother made her daughter believe
that her life would get better one day, and described a normal
existence of the past and the future in great detail.

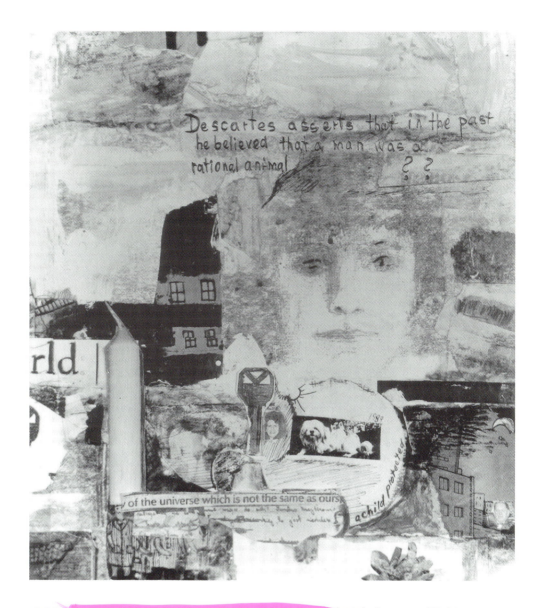

N. Mieses. "Reflection: Ode to Immortality of Motherhood" (1993). Courtesy of N. Mieses. "Descartes asserts that in the past he believed that a man was a rational animal . . ."

When Memory Speaks

Encouraged, the little girl kept a diary, wrote short stories, and painted little pictures about the life she was not able to live. With the support of her mother, the child was able to see the world in brighter colors, a fantasy that allowed her to forget the reality during those days, when danger lurked in every corner and any suspicious sound could result in their discovery. Both mother and daughter survived and were liberated in 1944 by the Russian Army.

In *Reflections: Ode to Immortality of Motherhood*, daughter N. Mieses pays a commemorative tribute to her mother who died in 1993. She continues to write and to paint.

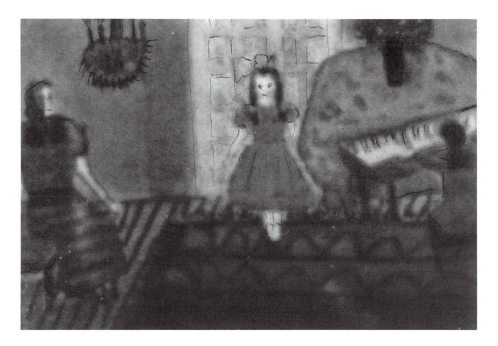

Antoinette Libro

The Tenderness of Photographs

Finding photographs of you, mother
when you were young
here you are in 1932
you and two other women
posing in a wooded setting
by the river

You, half-sitting, are closest to the river
and hold a flower in your left hand
while you stare pensively ahead
in sepia tones

Then, finding you again, much later
this time in 1962
you in your polka dot dress
smiling into the camera
holding the dog

Tonight a comet will flash
forty four million miles away
a satellite will ride the tail of the comet
telegraphing intelligence
back to earth

I hold your picture in my hand
you are forty four million miles away
transiting the universe–
I am earthbound
my fingers outstretched

to receive messages
unsure of comet or camera
knowing only the ancient need to receive–
to discover the secrets of the universe
locked in photographs
 —Toni Libro; reprinted with permission of Toni Libro

This poem, which appeared in *Waterways: Poetry in the Main-
stream* 8, no. 1 (January 1987), was written in memory of Dr.
Libro's mother.

Dr. Antoinette Libro is a dean of the School of Commun-
ications at Rowan University in New Jersey. She is a widely
published poet and author and a produced playwright. She
holds a Ph.D. from New York University.

George Segal

Internationally acclaimed sculptor George Segal created his
bronze life-size sculpture in 1984 as a memorial to those who per-
ished in the Holocaust. It represents a very important artistic state-
ment and has been placed in its permanent site in San Francisco's

When Memory Speaks

Lincoln Park, overlooking the Golden Gate Park. Segal's technique is to cast live models directly in white plaster. San Francisco's bronze, cast from the artist's original, was purchased by the Jewish Museum in New York City and installed in 1986.

In his haunting representational manner, casting living persons and using real props, Segal has condensed many of the horrific images of a manic devastation into one image. For the Holocaust pieces, he consulted photographs taken shortly after the Allied liberation of the camps.

Segal's work is represented in numerous private collections and museums throughout the world.

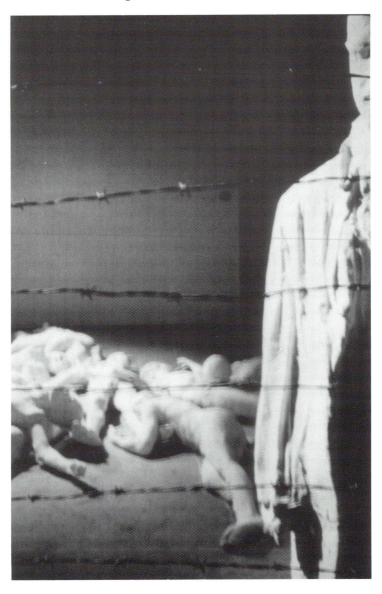

George Segal.
"Holocaust Memorial."
Courtesy of George Segal.

George Segal. "The Holocaust." Courtesy of George Segal.

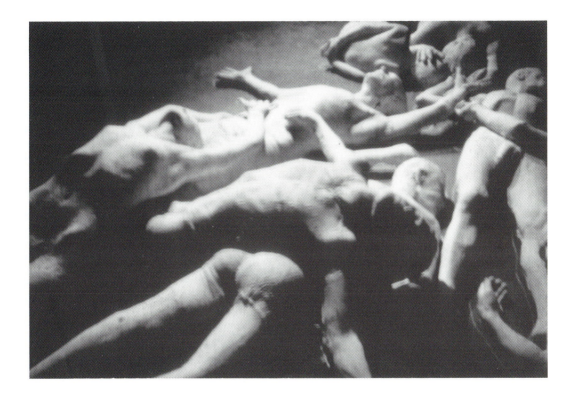

Mia Fendler-Immerman

Reflections

"On May 10, 1940, when German bombs fell over Belgium in an act of war, my life as a normal child came to an abrupt end. After the Nuremberg Laws which restricted the rights of Jews were put into effect, Jews were taken off the streets and from their homes never to be seen again. All of us sought flight to a safer world!

"Following numerous dangerous encounters with the authorities, my mother and I arrived safely in France. When my mother realized that my father had been arrested and

removed from our train, she decided she would return to Belgium to a bordertown called Givet and use her influence as a Belgian-born citizen to try to gain his release from the German Customs Officer.

"It was pouring out; black and grey clouds rushed menacingly by, as if to warn us of more danger to come. My mother sat by the window, her tears rolling down her cheeks. She suddenly turned to me, saying words I will never forget: 'If they come for me, you sit quietly without looking at me, you hear? You pretend you don't know me! I am not your mom!' I cried, pleading with her to take me along. She repeated her warnings, cold and firm. All of a sudden she seemed like a stranger to me. I didn't know then, she was saving my life!

"The noisy train, fueled by steam, came to a screeching halt. There was a knock, the compartment door opened, and the huge SS man from the day before entered. He was the one who had dragged my father out. He remembered my beautiful mother immediately and said in German, 'Allo Frau Fendler (her real name), come with me, please, your husband is waiting for you.' She pretended not to hear him, her red nails clutching her purse, still looking out of the window. She must have realized what a fatal mistake it was to come back here! She got up, grabbing her raincoat and overnight bag, without a glance for me, and walked out. I was left all alone! I sat near the window, feeling lost and cold, counting the trees,

Mia Fendler-Immerman.
"The Immigrants."
Courtesy of Mia Fendler-
Immerman.

the little houses, the clouds. Arriving in Antwerp, the city where I was born, I managed to get to our landlady's house. Exhausted and starved, I fainted at her doorstep.

"Years of hiding in different places with different people followed. There were cellars, attics, crawlspaces, orphanages, and castles. I roamed from one to the other, trying to stay alive. I never heard of my parents again, except for a stained

Artists' Retrospectives

Mia Fendler-Immerman. "My Mother, Father and Me." Courtesy of Mia Fendler-Immerman.

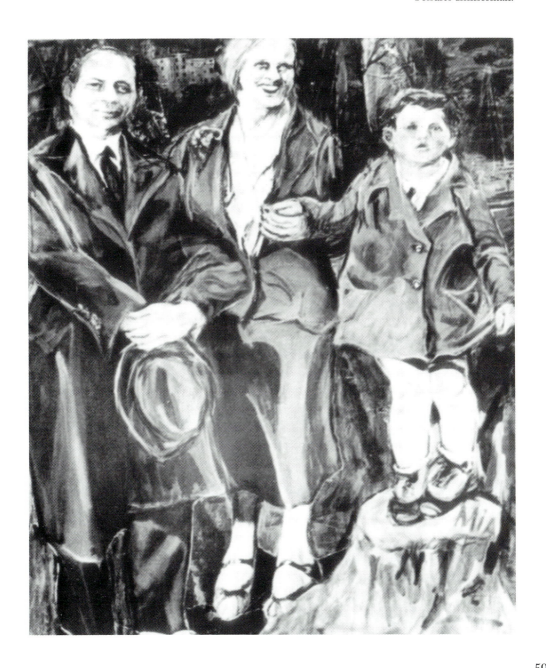

postcard from my father, addressed to our landlady. It read: 'I don't know where my beloved wife is, nor my little girl!' The rest was unclear; the card had been thrown out from a boxcar on the way to Buchenwald or Auschwitz. The only thing I ever heard of my mother was on a printed form from a local concentration camp in Malines, Belgium asking for working clothes, winter clothing to go far away.

"Today I keep my family alive by creating almost life-size portraits of their likenesses and surrounding myself with them. It sometimes dulls the pain of their untimely deaths."

Mia Fendler-Immerman. "Grand-mère et Filles." My grandma and her daughters. Courtesy of Mia Fendler-Immerman.

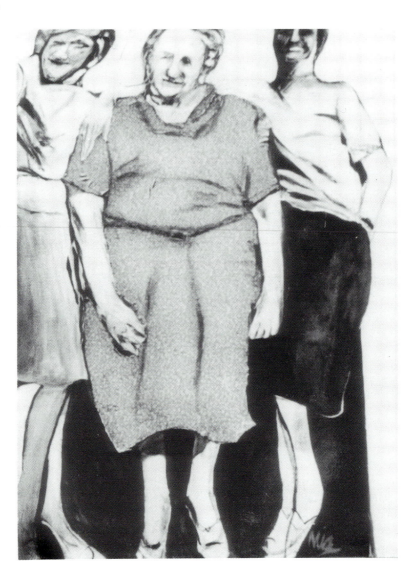

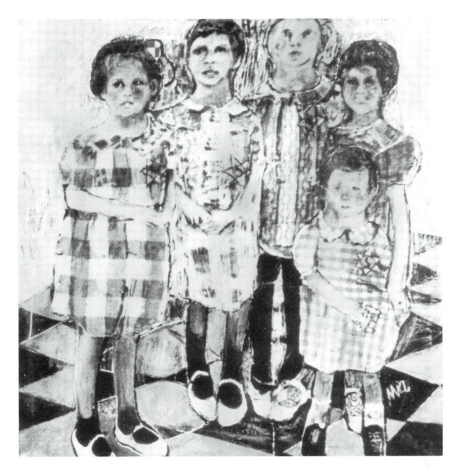

Mia Fendler-Immerman. "The Hidden Children." Except for the artist, all the members of her family were killed. Courtesy of Mia Fendler-Immerman.

Mauricio Lasansky

"The Nazi Drawings," the series of drawings by Mauricio Lasansky, were in preparation over a period of five years and were completed in the summer of 1966. In these works, the degradation of all humankind by its own brutality and avarice is unmercifully exposed in life-sized figures, depicting man's self-destruction.

The now-retired Lasansky (born 1914 in Argentina and a resident of the United States since 1943) managed the Printmaking Department at the University of Iowa, Iowa City,

When Memory Speaks

Iowa, and directed one of the most influential graphic arts workshops in the world. A Guggenheim fellow, Professor Lasansky has been honored five times by over two hundred and fifty one-man exhibitions since 1945. His prints are housed in over one hundred and fifty public collections in the United States and abroad, and his activities are recorded in eight published monographs.

In one of his drawings, Lasansky depicts skull-helmeted skeletal limbs emerging from the ribcage, with a uniformed figure. The figure itself is hardly visible except for the grimly

Mauricio Lasansky. "The Nazi Drawings." "Child Victim." 45 ½" × 43". Courtesy of Richard F. Levitt Foundation.

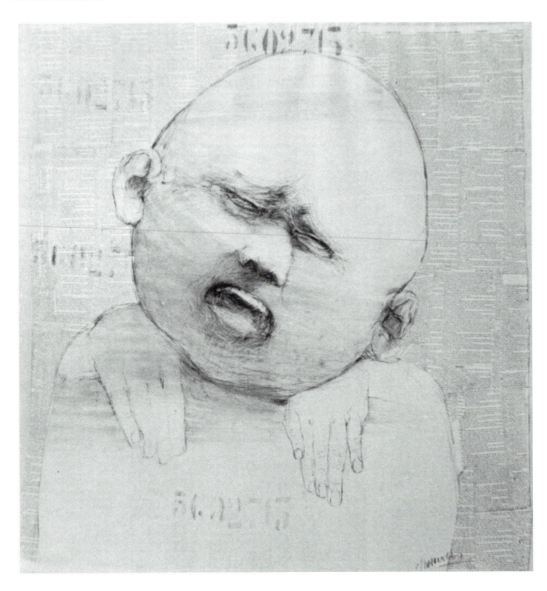

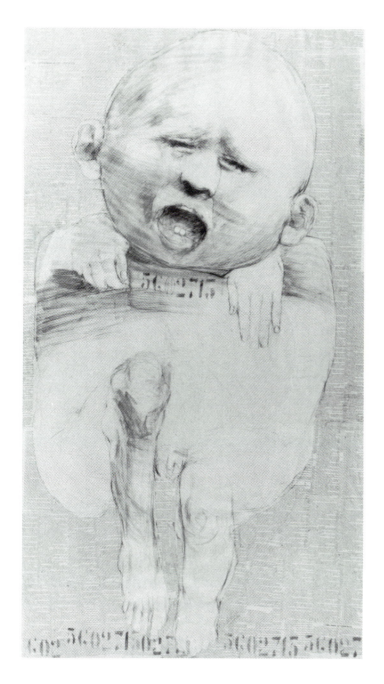

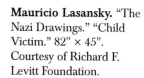

Mauricio Lasansky. "The Nazi Drawings." "Child Victim." 82" × 45". Courtesy of Richard F. Levitt Foundation.

locked three-quarter profile within the opening, formed by the skull's half-jawed roof under the teeth.

In another one, a half-dressed prostitute figure, with bald, moonshaped head, smiles slightly, half leering, with her eyes lost in the darkly penciled fuzz. With hands raised in the appropriate gesture, she reminds us of a woman trying on a hat; a kind of a web is thrown over her shoulders.

When Memory Speaks

Mauricio Lasansky. "The Nazi Drawings." A gassed figure with five victims and a grotesque skeleton sardonically tinkling a bell over their head. 75" × 45" lead pencil. Red, a water-based earth color, contrasts with the brown, a turpentine base. Courtesy of Richard F. Levitt Foundation.

His work presents a tireless procession of the tatooed; the concentration camp numbers seemingly perforate the portrait drawings. Penciled webs, retracted lips over horror-grinning teeth, are reiterated motifs for Lasansky, ending in a crescendo of unanswerable deprivation.

Lasansky does not flinch from accusing the religious:

It is done, it is finished, but we endure, the folded hands and facial expressions in the drawing seem to be saying. The dark

ravaged face of the bishop glares out with an insane defiance, so much at odds with all the composed panels of religious pictures displayed on his shawl, that is, except for the one panel where a green money bill glints. The darkness in the bishop's face extends to the cassock of the smug attendant priest grimly wedged into the bishop's left side. The heavy black cassock of the priest momentarily teases the memory until we recall that it is made of the same stuff as the dark webbing of the executioner's gown in the earlier drawings. Then, as if to confirm the association, one notes lying in a pile a frieze of infant corpses on which the clergy are standing. The whole composition tingles with tragic irony which points back to the majestic medieval portraits of saints and church fathers standing on a pediment of lions and wild beasts—the church triumphant! Here the priest's red sash drips down upon the children's dead bodies.[1]

Audrey Flack

A leading photorealist and a foremost woman artist who has achieved many distinctions, Flack is the first photorealist to have had a work purchased by New York's Museum of Modern Art. She has exhibited in museums throughout the world.

Audrey Flack's large and impressive painting "World War II," which expresses the suffering of the Holocaust victims, was exhibited in the early 1980s in the Academy of Fine Art in Philadelphia. She shares her feelings with her audience through her personal language of art:

"My idea was to tell a story, an allegory of war, of life, the ultimate breakdown of humanity. The Nazi. . . . After reading *Dawn* and *Night* by Elie Wiesel and *The Survivors* by Terrence Des Pres, I was convinced of the existence of pure evil as well as the existence of beautiful humanity exhibited by many of the survivors of the concentration camps.[2]

"I wanted to create a work of violent contrasts of good and evil. Could there be a more violent contrast than that? I decided to use Margaret Bourke-White's photograph of the Liberation of Buchenwald. The prisoners in their striped uniforms, hollow faces, stunned expression as an example of Nazi brutality. I chose specifically not to show blood or injury. Too much blood has been shed already. I did not want to capture the audience that way. But I wanted to shock. I did this by contrasting the image of the survivors with the sickeningly sweet pastries. I found a quote for Hasidic Rabbi in Roman

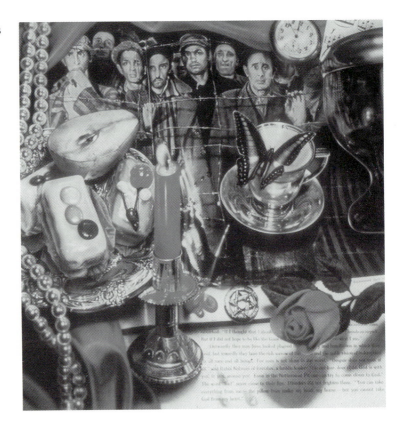

Audrey Flack. "World War II." 96" × 96"; oil over acrylic on canvas. Based on photograph. Courtesy of Audrey Flack.

Vishniak's book *Polish Jews* that deeply touched me. The innocence, the beauty and trust in God and humanity were overwhelming. I decided that would be a good contrast to the Bourke-White photograph, for the viewer to look at what happened to these people who could see, hear and speak no evil.[3]

"I wanted to seduce the viewer into the work and hold his attention long enough for him to read the quotation and then become involved with interpreting the symbolism. I am involved with the audience. I want them to become involved with the work. The silver dish with the embossed roses, the lavishly flowing pearls, the sickening sweet petit fours are part of contemporary life, the vanity of the Vanities. Offering still another contrast, opulence and deprivation. Many people were disturbed by the juxtaposition of the pastries with the starving prisoners. It was meant to raise consciousness, but in many cases it raised guilt. Were we not all eating at that time?[4]

"Conservative critics trained to accept paintings of worn boots or unwashed dishes in a sink have difficulty with my work. Impressionist still-life objects were permissible. Beads and pearls, silver and pastries were seen as a violation of the Post-Impressionist and Modernist code."[5]

In Flack's still life, a butterfly finds its way among the victims. "I looked for butterflies for a week. I had to have a blue one and it was not easy to find."[6]

Sophia Richman*

"Hidden Traumas: Zosia and Lina"

"In my adolescent years, I discovered the wonderful feeling of expressing myself through painting. In my twenties I left art for the profession of psychology, and now about thirty years later I return to painting with a different perspective. This painting referring to the Holocaust is my first attempt to capture some of my inner feelings about living through trauma in the past and present.

"The older child in my painting is Lina, my daughter at age 13, who as the second generation has inherited the legacy of the Holocaust, but has her own personal tragedy as well. As she poses for a photograph captured in this painting, she is unaware that deep within her brain is a hidden tumor that will emerge a year later and transform her life. Today at fifteen, she too is a survivor in her own right.

"The theme of hiding is profoundly significant for me. The first four years of my life were spent in hiding, hiding in plain sight under a false identity. In later years, I continued to hide in a different sense. Few people knew of my traumatic past.

"It is only in recent years that I have felt more ready and safe to come out of my hiding, to begin to come to terms with my past and integrate it into my current life. That process has been facilitated by piecing together the story of my early years of my life and telling it to others as I do here.

"My parents were college graduates and professionals. When I was five months old, the Germans invaded Lwów and began their reign of terror. My father was imprisoned in Janowska, a concentration camp.

"We had the good but ironic 'fortune' of not looking Jewish; my mother's Polish was perfect and I, a blond blue eyed baby named Zosia, could easily pass for a Polish toddler. With the help of a good Gentile friend and her connections in the clergy, my mother secured the marriage certificate of a deceased Catholic woman and took on her identity. She had me bap-

*Excerpts courtesy of Sophia Richman.

tized and we moved to a neighboring small town where no one knew us. For the following two and a half years, my mother became a devout church going Catholic whose husband, a soldier in the Polish army, had disappeared.

"In December 1942, my father made a daring escape from Janowska Camp. He tracked us down. My mother with her great courage found a hiding place for him in the small attic that was part of the upstairs apartment we rented. This attic remained his secret home until our liberation by the Russians in July, 1944. During the days, he occupied his time in the attic by writing about his concentration camp experience. He finally published this account in 1975.

"The terror of being discovered was a constant presence in the years of hiding. Some of my earliest terrifying memories date back to those years when my father reappeared in my life. At first my mother cautioned me to stay away from the attic

Sophia Richman.
"Hidden Traumas: Zosia and Lina." Zosia survived as a child in Poland. Courtesy of Sophia Richman.

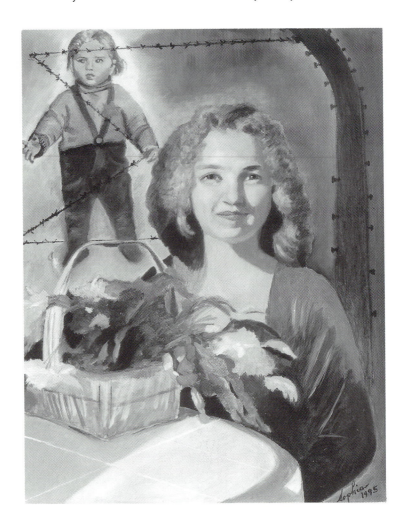

door warning me that there was a dangerous wolf inside. Once when I was alone, the attic door suddenly opened and to my horror a stranger emerged. Later, when I knew the stranger to be my father, I had another frightening experience. My mother had left the apartment to run an errand, and my father came out to be with me. Hearing voices from our apartment, the landlady asked who was with me. My terrified father motioned me to not expose his presence and I told the woman behind the door that I was alone. As a three year old I apparently grasped the significance of keeping his existence a secret.

"In America, I became a psychoanalyst, married, and had a child, but in the background, behind the barbed wire of repression, was little Zosia terrified to express her thoughts and feelings in a dangerous world where people cannot be trusted and the consequences of mistakes take on life and death proportions."

Sidney Goodman

"Spectacle"

Sidney Goodman is one of our foremost contemporary figurative artists. For over thirty-five years, he has painted art from the everyday world with sometimes disturbing over-

Sidney Goodman. "Spectacle." Reflections on the bodies found after liberation in camps. 76 3/4" × 124 1/2"; oil on canvas. Courtesy of Sidney Goodman.

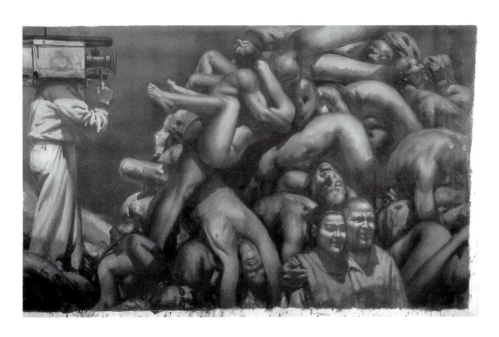

tones, whose precise meaning is nearly impossible to resolve.

According to Dr. John Ravenal, curator of the Philadelphia Art Museum, in "Spectacle," Goodman has created an image whose references are at once specific and universal.[7] The jumbled bodies he depicts directly recall the famous photographs of concentration camp victims that Goodman, together with a nation of disbelieving Americans, first saw in *Life Magazine* in 1945.

Goodman's work, viewed as witnessing a central issue, is shown through the experience of trauma in the art of the Holocaust. Between seeing and not seeing, the camera man looks directly at the pile of bodies in a highly selective way. They are the victims who saw firsthand, and they are eloquent in their silence.

Sidney Goodman was born in 1936 in Philadelphia, the son of Russian Jewish immigrants. He studied drawing, painting, and printmaking, and he teaches at the Pennsylvania Academy of Fine Art in Philadelphia.

Goodman emerged in the early 1960s as one of the leading American artists in the return to the human figure as a primary subject, and he has remained an influential force in contemporary art for more than thirty years. His work is in the permanent collections of various museums in the United States. A major solo retrospective exhibition of his work was held in the Philadelphia Museum of Art in the spring of 1996.

Ann Shore*

"I was born in a small town in Poland named Zabno, a place I, as a child, loved. The whole town was our playground and all the Jewish people our family. One day it all disappeared. On March 10, 1942, in the middle of the night, German soldiers smashed down the door of our house looking for my father. They found him hiding in the cellar and shot him to death. I was only twelve years old.

"Shortly after, my mother, sister, and I fled to a neighboring village looking for a place to hide. We located a poor widow with four children who in exchange for all our belongings agreed to let us hide in her hayloft. After a few months, when we had nothing left to giver her, she ordered us to leave but my mother refused knowing that if we left we would be caught and killed. She allowed us to stay for she realized had she revealed our presence she herself would have been in danger.

*Written by Ann Shore.

Ann Shore. "Seeds of Time." 50" × 54"; acrylic on canvas. Courtesy of Ann Shore.

Ann Shore. "Renewal Series." Pastel oil sticks on paper. Courtesy of Ann Shore.

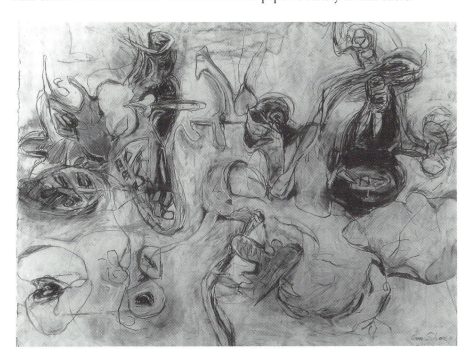

To punish us she took away the ladder to our hayloft and severed all contact.

"We were totally alone, without food or water, infested by lice, constantly hungry, surrounded by Polish farmers who were on the lookout for Jews, hoping to catch them and denounce them to the Germans for a reward. Despite the danger, my mother and I would climb down from our hiding place each night to scavenge for a meal. I climbed trees for fruit, stole rotten potatoes from pigsties, and drew water from a stagnant pond.

"The fear of being captured was constant; the rustling of branches and the barking of dogs terrified me. I sat day after day with my face pressed against a crack in the wall watching the peasant children laugh and play in the yard. In winter, when freezing wind penetrated our hayloft, our down blanket, our most precious possession, would become covered with a layer of ice, but we huddled together under it. When the pond froze over and we were unable to draw water, we licked the icicles that hung from the eaves of the roof.

"After two years in the hayloft, the widow's brother arrived and threw us out. We wandered in the woods for several days and came upon a sixteen-year-old boy from our town who had been hiding alone in a barn. He took us in for the remaining six months until the end of the war.

"Only 15 Jews out of 700 from Zabno survived. For forty years I suppressed my past. I raised a family, immersed myself in painting, and exhibited widely. Through abstract images of nature, I created a world of transmutation and regeneration: sweeps and strokes of light-filled tones became my metaphor for celebrating the beauty of being. In 1991, with several others I organized the first International Conference of Children who survived the Holocaust by hiding. In 1994 I became the president of the Hidden Child Foundation/ADL. Our mission is to teach young people the consequences of bigotry and hatred, and to pass on our legacy to future generations."

Jacob Barosin

Jacob Barosin's massive six foot by three foot pencil drawing, "L'Kidush Ha-Shem," speaks to us from behind the ashes in the wind; his art spiritually reaches beyond the concentration camps which he survived.

Jacob Barosin exhibits his work in the United States. He resides in New York.

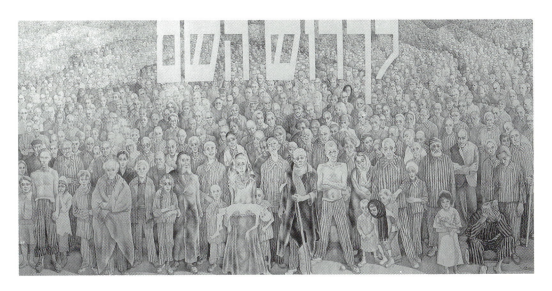

Jacob Barosin. "L'Kidush Ha-Shem." 6' × 3'; pencil drawing. Courtesy of Jacob Barosin.

Marlyn Ivory

"The Night Sky Cried"

In describing the soul of the Holocaust, evoking grief for the dead and hope for the survivors through paint, Ivory's words express her personal beliefs.

The Night sky cries out in sorrow and the earth moans. Mourners emerge from the landscape in silent prayer for the loss of the innocent. These faceless people revealed by moonlight slowly journey towards the light.

Heartbreak and despair are the source of this brooding image that seems to hold tears in transparent veils of sadness. Guache and ink washes form the moody turbulent clouds that become one with the land and the figures.

The holocaust, that unbearable tragedy, will forever be part of the sadness within all mankind. From the depths of grief, anger, love and hope comes a message to the world of survival of the human spirit and the celebration of life.

Ivory, echoing Lily Lustig Redner's thoughts of resilience

when she spoke of going "beyond the pain, reaching out, and making something constructive and positive out of her destruction and pain," brings us a message of hope.

Marlyn Ivory has been painting since childhood. She earned a Master of Fine Arts from the University of Pennsylvania, and a Master of Education from the Tyler School of Art, and studied at the Barnes Foundation. She has taught in several universities and has exhibited in over one hundred shows.

Marlyn Ivory. "The Night Sky Cried." 14″ × 18″; guache and ink. Courtesy of Marlyn Ivory.

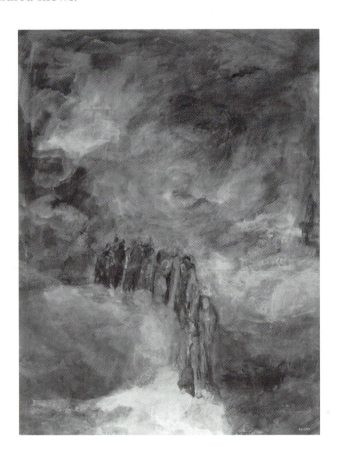

Kitty Klaidman

Kitty Klaidman, a hidden child during the Holocaust, was protected by a Christian neighbor, Jan Velicky, who together with farmers, the Drinas family, provided refuge for her and her family. The Klaidmans lived in an attic space of the farmhouse for two years, and Kitty's visual memory of her youth is

heavily involved in recalling long periods of dreadful anxiety.
Her "Hidden Memories" is a series of paintings that focus on
these attic spaces. They carry with them some ominous over-
tones, but they also convey a sense of abstraction that can
lead to non-Holocaust interpretations. "Ghost Games" juxta-
poses the views down circular staircases with old family pho-
tographs. "Childhood Revisited" is a mixed media series that
peers at the past as if through shaded, aged photographs.

Fifty years ago Kitty Klaidman lived in that windowless
room with her parents and brother during World War II. It was
a storage space about 7 feet wide and 12 long with a dirt floor,
some bags of grain and potatoes, and a rickety staircase leading
to the trapdoor that opened into the forbidden attic.

They never left their dark room—not to eat, nor to walk,
talk, bathe, or breathe. They rarely spoke and then only in
whispers. There was nothing to do and no light in which to do
it, except at the top of the stairs, where pale sunlight filtered in
from a tiny attic window, and sometimes she (then only 7)
would sit at the top of the stairs with her 11-year-old brother
and look at the light. He called that "going into the world."

Kitty Klaidman. "Hidden Memories: The Attic Corner." Our hiding place.
40" × 60'; acrylic on paper and aluminum. Courtesy of Kitty Klaidman.

Kitty Klaidman.
"Hidden Memories: Trap
Door 1." 60" × 40';
acrylic on paper and
aluminum. Courtesy of
Kitty Klaidman.

When the Russian army liberated the little village where
they were hidden, she was too weak to walk. "It took me a
long time to learn to speak loudly, and I had to be basically
carried back home," Klaidman recalled. "But," she added "I
don't really remember desperate times."

Such are the memories of children and often of adults: they
survived the Holocaust, but they cannot recall what they
endured. More than forty years passed before Klaidman, an
artist, began to confront her past and allude to it in her paint-
ings.

76

Elyse Klaidman. "Blocked Vision" (1992). Daughter of Kitty Klaidman (born in New York) reflecting on her mother's fate during the Holocaust. Courtesy of Elyse Klaidman.

In "Hidden Memories: Attic in Sastin" (exhibited in 1992 at the Minnesota Museum of American Art), Kitty Klaidman shows the attic of the childhood home she fled in western Slovakia and alludes to the farmhouse where she and her family hid about one to two years.

Kitty Klaidman has exhibited her work widely in the United States and Europe; Elyse Klaidman, her daughter, also a painter, has exhibited her own art and teaches art in California.

Kim Fendrick

If We Live

The Hidden Children Book explores the stories of lost and hidden childhoods. One of its chapters about Kim Fendrick, who survived in Poland in hiding and clearly recalls the Nazi's occupation of Zloczów, her little town in southeastern Poland:

> I dutifully sat at our dining room table and wrote my name, over and over again, almost as a sacred message. "This is my book," I repeated to myself. "This is my special book. And this is my name, my special name." My grandmother could not see the point in my practicing.
>
> My mother responded to her mother with words which resonate in my ears over the past 54 years: "If we die, she will have been kept busy. And if she lives she will know how to write."

Of the 15,000 Jews living in Zloczów fewer than 200 survived.

This section is adapted and used by permission of Kim Fendrick.

Elizabeth Koenig

Elizabeth Koenig (born Elizabeth Kaufmann) was born in Vienna, Austria. Her father was a well-known writer, editor, and journalist who lived in Berlin until Hitler's access to power. After Koenig and her family returned to Austria, her father's name was put on the blacklist as an anti-Nazi writer. After the "Anschluss" in 1938 they could not obtain a foreign visa, but they eventually fled to France.

In 1940, after her father and brother were put into a detention camp for aliens, both mother and daughter succeeded in fleeing Paris. They walked, hitchhiked, and bicycled to the south of France.

Deprived of formal schooling, Koenig kept a diary at the age of 16 and illustrated it with her sketches. Her pictures depict the flow of refugees on the roads from Paris to unoccupied France in June of 1940. Together with her parents, the girl hid in various places until she arrived at Le Chambon-sur-Lignon in June 1941, to the home of the humanitarian Pastor Andre Trocmé and his wife Magda. The couple saved hundreds of children by organizing the entire mostly Protestant

village as a place of rescue. Both Pastor Trocmé and his wife Magda were honored after the war.

In 1941, Koenig's father obtained a special visa to the United States provided for endangered European intellectuals through the agency of the American Varian Fry of the Emergency Rescue Committee. Koenig and her family crossed the border from France to Spain on December 7, 1941, the day of Pearl Harbor. At about the same time that the exits from Europe closed and after an arduous trip through Spain and Portugal, the family arrived in Virginia Beach on one of the last boats to cross the Atlantic in 1942.

Koenig continued her painting (at Hunter College, the Art Students League, Salzburg-Akademie der Bildenden Künste, and Brussels-Academie des Beaux Arts) and in 1990, she designed a stained glass window to memorialize the Holocaust. It depicts fear, but it also expresses some hope. In collaboration with Kay Hedlund, she continues to design stained glass windows. Her project is designed to encourage hope and to over-

Elizabeth Koenig. "Flow of Refugees." Watercolor (from a young girl's diary). On the road from Paris escaping to the South of France. Painted in 1940, when the artist was 16. Courtesy of Elizabeth Koenig.

"Never Again." Stained Glass Window. Designed by Elizabeth Koenig, executed by Kay Hedlund.

come differences of body, mind, and spirit by reaching out to build bridges as opposed to walls.

A graduate librarian for forty years, Koenig was appointed director of the Library of the United States Holocaust Memorial Museum in Washington, D.C., in 1989. She is now retired.

Netty Schwarz Vanderpol

Netty Schwarz Vanderpol was born in Amsterdam; she was 13 years old when Nazi Germany invaded the Netherlands. She was a classmate of Anne Frank.

In 1943, Vanderpol and her family were deported to Wester-bork concentration camp and then Theresienstadt, north of Prague; she was placed on several deportation trains for Auschwitz, only to be removed at the last minute. In February 1945, in the only such exchange of the war, she and a group of fellow inmates from Theresienstadt were sent to Switzerland in exchange for German prisoners of war.

Vanderpol started doing needlepoint in 1984 as a vehicle for dealing with her emotions. "Every Stitch a Memory" represents abstract art.

Some of Vanderpol's works contain direct Holocaust imagery, such as the Star of David with the Dutch word "Jood," barbed wire, concentration camp numbers, vignettes of flowers that grew near the perimeter fence at Theresienstadt, and train tracks. One work, "All the King's Horses and All the King's Men," a needlepoint design, includes a broken mirror as testimony to a broken life.

Vanderpol has been compared to some of the abstract expressionist artists of the post–1945 period. Each of her works contain quiet and controlled symbols and perhaps an inner rage. Powerful textures of the yarn itself are woven into evocative designs, which reflect the artist's disturbance. Her work is mostly Holocaust-specific but it also has a universal expression of grief.

Netty Vanderpol. "Every Stitch a Memory." Theresienstadt. Courtesy of Netty Vanderpol.

When Memory Speaks In Vanderpol's works, needlepoint, a feminine medium, has been raised to a contemporary art form.

Martin Itzkowitz

Afterword

alone
in lengthened shadows
of diminished day
the rabbi sinks
in his seat of honor
shrivels, shrinks
bowed in a black suit
with downcast gaze

the sexton's deputy
who jesting once
astroll amid the aisles
swore he knew
a single blessing
—over schnapps—
amends all raucous stalking
silent now, mirthless
in his slow and dark patrol

one by one
the faithful enter
(with a distant nod)
and soon succumb
(well spaced)
to speechless solitude;
the skeptic sits beside his son
just come of age:
equally apart

 we knew
(in that gathered hush and gloom)
scant years after auschwitz
bare decades past the last blood libel
since the last pogrom

 we knew
(it was our own shaved heads, slit trouser legs,
our own skins lashed with leather and the metal clamps)
confirmed in millennial memory

 we knew
(charged with untold voltages of sabbath light)
that friday afternoon
they killed the rosenbergs
that it could happen
again

—Martin Itzkowitz

Martin Itzkowitz teaches writing at Rowan University. "Afterword" is part of the open-ended collection *Brunzvl* that he is currently preparing for publication. His work has appeared in numerous journals and magazines.

Eric Lager

"The Burning of the Books"

"The Burning of the Books," drawn by Dr. Eric Lager, a Philadelphia psychiatrist, appears in Marilyn Lager's book *Sigmund Freud, Doctor of the Mind* (1986). This drawing commemorates the European catastrophe through art and print.

In her book, Marilyn Lager describes Freud's fear that humanity would sink into a "blood bath." In 1932, Freud signed and circulated an appeal to the Geneva Antiwar Congress and

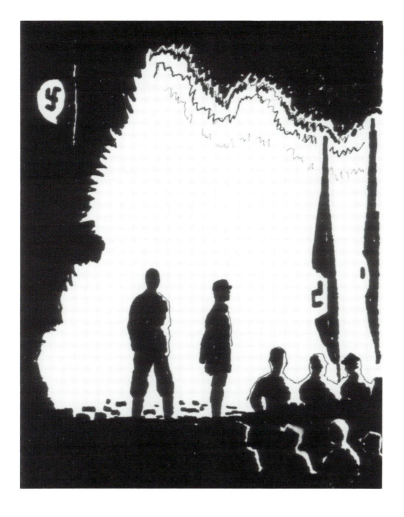

Eric Lager. "The Burning of the Books." Courtesy of Dr. Eric Lager.

urged doctors of all countries to put a halt to the horrors of war. In the first month of 1933, he learned that the writing of the great thinkers had been publicly burned, and he heard Goebbels' infamous statement that the period of "intellectualism is over." As Freud commented: "What progress we are making. In the Middle Ages they would have burnt me; nowadays they are content with burning my books." Sigmund Freud was able to leave Vienna before he, too, could be destroyed.

Eric Lager was born in Vienna, Austria. In depicting the Nazis' burning of the books, he reflected on his own childhood escape from Vienna in 1939. After numerous obstacles, he arrived safely in Switzerland with his parents, and although not interned in Swiss working camps for Jewish refugees, he was forced to be separated from them. Lager was reunited with his parents before they all made their escape to the United States.

Marlene E. Miller

"Schlafwagen: Who Will Say Kaddish for Them?"

"Schlafwagen: Who Will Say Kaddish for Them?" is the third sculpture in the series, "Zachor: Remember!", a visceral commentary about the Holocaust and its intention (to victims) to annihilate an entire people simply because of their religious beliefs.

"The third piece evolved after my extraordinary journey to Poland and Israel in 1992 with "March of the Living." Joining with 5,000 Jewish high school students, adults, and survivors of the death camps, we paid tribute to the memory of six million European Jews who perished. Through deliberate starvation, brutalization, gassing, and burning, the Shoah (the destruction) was wrought. Incomprehensible and inhuman acts were perpetrated by very average, normal, and rational people—an evil which was tolerated and frequently abetted by the citizenry.

"Our journey brought us to sites where, for centuries, Jewish communities once existed, contributing to commerce, religious scholarship, educational institutions, culture, scientific advancement, and literature—all silenced. We saw only a ghost of the Warsaw Ghetto, a small but significant reminder of what was— a section of the infamous wall still standing; we paid tribute to the resistance fighters buried under the mound that once was

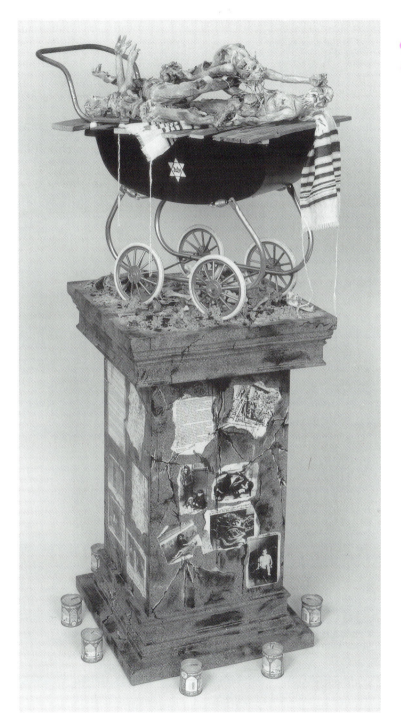

Marlene E. Miller.
"Schlafwagen: Who Will
Say Kaddish for Them?"
(1993/94). 2' × 2' × 5'.
Courtesy of Marlene E.
Miller.

their secret bunker—Mila 18; we stood in the Umschlagplatz where Jews of every age were collected, forced into cattle cars to be resettled, and we witnessed those places to which Jews from all over Europe, from cities and villages, wrenched from families and friends were sent—the death camps. Treblinka was eradicated—in its place, a beautiful, brooding forest and a magnificent monument to the dead—a city of rocks and stones representing the thousands of communities from which Jews were torn. Majdanek, Auschwitz, and Birkenau stood intact; watchtowers, barbed wire fences, barracks, showers, gas chambers, ovens—intact; Judenrein free of Jews, except for us!

"Five thousand of us silently marched the two kilometer road from Auschwitz to Birkenau, paying homage to those Jews who took the same path years before. Although the allies were nearby and the Germans were retreating, it was still the intention of the Nazis and their collaborators to finish off the Jews.

"We walked the path of our people and mourned them, honored them, and remembered them. At these sites, we left behind thousands of small, glowing memorial candles, 'Yahrzeit' candles, burning under the infamous entrance sign to Auschwitz, 'Arbeit Macht Frei,' and the evil looking archway through which the trains came to Birkenau. These candles burned at the gas chambers and they burned beside the railroad tracks, and they clustered in light on the twisted, charred metal stretchers inside the ovens. These flames of remembrance lit up the black corners of the Shoah so that we might see and say, 'Never Again!' . . . 'ZACHOR: REMEMBER!' "

Marlene E. Miller, exhibits both in the United States and abroad. She is a Professor of Fine Arts at Bucks County Community College in Newtown, Pennsylvania.

Renée Roth-Hano

To My Mother

"I guess she decided to exit as she had lived, fiercely independent.

"Our relationship had definitely changed since her first heart attack two years before.

"I was able to see her for the first time. This life-worn woman who best expressed her love through cooking and knitting, who never abandoned her blind mother and per-

formed miracle after miracle getting our French citizenship in time, digging up a military truck to help the family flee from Nazi-occupied Alsace, finding an apartment in Paris when no one else could, obtaining false ID papers for herself and my father, resolving to part with her children for their safety— saving our lives! And making darn sure that her daughters get what she was denied—like coming to America.

"Women have been the silent backbone of society for centuries, but the Holocaust years, especially, have brought to the fore the quiet heroism of these humble but oh! so wise and determined women. And not only Jewish women. I am reminded of the two nuns who hid my sisters and me at the risk of their lives—and particularly our Mother Superior, who bicycled daily through the countryside to gather food during heavy bombing and shelling even though, I found out later, she was terrified. Sadly, after the war, she lost her life during a bombing attack during the Algerian war.

"I still dial my mother's number, unthinking, and catch myself half-way knowing that the phone would keep ringing and no one would ever answer again.

"I know that it will be easier for me to die when the time comes: she will be waiting for me on the other side."

Author of *Touch Wood: A Girlhood in Occupied France,* and its sequel, *Safe Harbors,* Renée Roth-Hano survived the war in a convent in France. She became a devoted Catholic as a young person and returned to Judaism after the war.

This section was used by permission of Renée Roth-Hano.

Joseph Hahn

Joseph Hahn, a year before World War II began, experienced violent antisemitism at the University in Prague and managed to flee to England.

His work has been widely exhibited, and a volume of his poetry was published in Switzerland. In the 1990s the Academy of Arts in Honolulu arranged an exhibition that juxtaposed Hahn's drawings with Goya's "Horrors of War."

Joseph Hahn, born in 1917, studied art and poetry in Prague, Czechoslovakia, and Oxford, England.

Joseph Hahn. "Portrait of My Father Siegfried Hahn." Pen and brush with ink (1947). Copyright by Joseph Hahn. Courtesy of Joseph Hahn.

Libbie Soffer

"The Nameless"

"Because I'm a visual artist I decided to pay tribute to the women who have gone unnamed through history in a sculptural form using metaphors of universal existence. I bound a traditional book in nontraditional binding that includes fabric pages tied together with rope and stained with "blood," the life force. Through that blood we are all joined. Women have created all the yesterdays and will continue making all the tomorrows. Wars will continue to be a plague as long as man walks this planet. But women, mothers, will make life, so long as our blood does its cyclical flowing.

"These thoughts put me clearly in touch with the realization that women all over the world were the real heroes of history and of the Holocaust, the most destructive period in history."

Libbie Soffer, a textile artist, has exhibited widely in numerous solo and group shows and teaches at Wallingford Community Art Center in Wallingford, Pennsylvania.

Libbie Soffer. "The Nameless." Courtesy of Libbie Soffer.

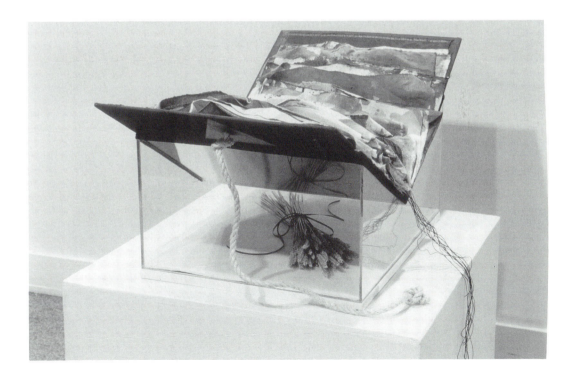

Suzanne Reese-Horvitz and Robert Roesch

"The Second Wall of Tears"

A glass and aluminum installation by Suzanne Reese-Horvitz and Robert Roesch symbolically mirroring the ancient Wailing Wall in Jerusalem invites interaction between the viewer and the conceptual structure. The glass panels refer to the tragedy of Kristallnacht.

The installation measures 16 feet by 16 feet by 16 feet. It is a collaborative work by Suzanne Reese-Horvitz and Robert Roesch, whose primary medium is glass.

Suzanne Reese-Horvitz has exhibited both nationally and internationally. She often collaborates with her partner, sculptor Robert Roesch.

Suzanne Reese-Horvitz and Robert Roesch. "The Second Wall of Tears." 16' × 16' × 16'; glass covered structure with gold and silver leaf, nine sided with no ceiling. Courtesy of Suzanne Reese-Horvitz and Robert Roesch.

Suzanne Reese-Horvitz and Robert Roesch. "Shedding Golden Tears." 192" × 156" × 72"; glass, gold leaf, enamel towers and structure of steel/sandblasted glass, gilded and screened. This work mourns the victims of the Holocaust. Its twenty-five glass windows contain text and images relating to definitions of sorrow. Courtesy of Suzanne-Reese Horvitz and Robert Roesch.

Harry J. Beethoven

Harry J. Beethoven (1903–1990) was a self-taught artist who, after the age of 60, created many diorama sculptures. He sculpted three Holocaust remembrance pieces, two of which are shown here. The dioramas contain hundreds of small figures, each cast by the artist from a metal alloy. The scale is one-half inch equals six feet. Among his works are "Car 11688."

Beethoven immigrated to the United States from Russia as a young child. After his retirement as a lawyer, he created over twenty diorama sculptures.

Harry J. Beethoven. "Car 11688." Beethoven shows a mass deportation of Jews under the watchful eye of armed guards. The infamous slogan of Auschwitz, *Arbeit Macht Frei* ("Work Makes Free") is formed in dead bodies (see detail). Photo by Jerry Mesmer. Courtesy of the family of Harry J. Beethoven.

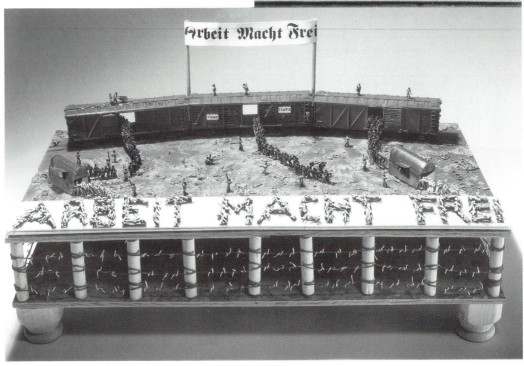

Sara Nuss-Galles

"Remembering Prywa Lukowska Nuss"

Chocolate covered rum balls,
Coarse black bread, creamy farmers cheese
A fine woolen blazer, never worn.
Pleasures postponed, your credo.

Was it wanting that was dangerous?
Did you fear desires could weaken
Pleasure might be irresistible and sweet
Erasing memory.

Flight over bodies, my brother's hand in yours
(Inside your womb another son)
Chaos, two alone midst bombs and shooting
A Jewess saved with his life by a Polish soldier

Seldom did you speak your losses aloud.
I struggle to know my grandparents, aunts, uncles
Cousins who might still have you, Tante Prywa
Had they survived
I barely know their names.

Minute droplets of emotion welled
Joy was hard for you
And ever-overhead hovered envy
The evil eye poised to devour a proud moment

Lest jealousy be aroused
You boasted not
Expressed feelings timidly
Praised seldom
Then hastened with spit and "poo-poo-poo"

I longed for June Cleaver hugs
A high heeled mother with a feather duster
Instead, house-dressed,
You caressed with soup and potatoes
Unfaltering strength
Your life for mine without a thought.

When Memory Speaks

Mementos evoke you
Cherry nubbed lipstick, a worn, quilted robe.
That special tenderness
Only your grandchildren would know.
With them alone, the fierce survivor could rest.

Passing years
Have made my face a mirror of your dear face.
And always, rum balls, black bread
Your cherished blazer, now mine.
Bring you and tears to our eyes.

— © 1997 Sara Nuss-Galles

The university writer for Drew University, Sara Nuss-Galles's personal essays, fiction, poetry, and humor have appeared in various anthologies. She was born after World War II in Kirghiztan in the then-USSR to Jewish refugee parents fleeing Nazi-occupied Poland. After leaving the USSR, the family lived in the former concentration camp Bergen Belsen, which had become a Displaced Persons Camp, before immigrating to the United States.

Samuel Bak

An internationally recognized Israeli artist, Samuel Bak has reflected on his personal experience as a child living through the Holocaust and the destruction of human life, through usage of multilayered symbols filled with pain and despair. His sad experience of the *Shoah* and its aftermath with ever present memory underlie Bak's work. Using beautiful and rich hues, he makes references to the art of the past and to the work of the great masters, with all its tonality, dimensions of space, and aerial perspective. At the same time, his work with its symbolism and emotional perplexity conveys a surrealistic quality and often appears puzzling to the viewer. In his depiction of pears that are often battered or armed he evokes an image of the human figure with its upright posture and fragility. This image embodies his concerns and his personal iconography in various forms.

Bak frequently depicts pears as metaphors for the destruction of people and as the tragic consequences of the Holocaust. "I hope that the components that make up my paintings," says Bak, "will somehow convey a feeling or certain memories of hard times, of war-time existence that I have

experienced myself, and the war-time terrible images bombarded constantly even when we are sheltered and live happily in a very comfortable space on our islands."[8]

While discussing the idea behind his latest series of pears, Bak tells us:

> As a child I had a feeling that if Adam gave up paradise in order to taste the fruit that would give knowledge and a capacity to distinguish between good and evil it must have been a pear. I felt that an apple, which in my childhood memories was usually very sour, had nothing in common with the sensual, wonderful taste of a pear.[9]

Samuel Bak. "The Family." 63" × 78.75"; oil on linen. Courtesy of Pucker Gallery. Copyright © by Pucker Gallery.

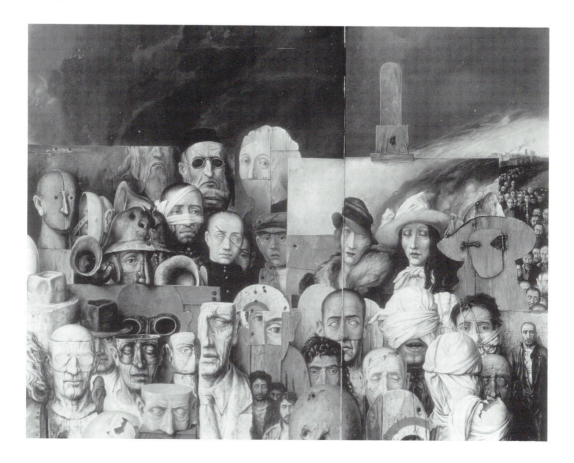

Samuel Bak. *Left to right.*
"Moving" (1988), 39.5" ×
32.5"; "Alone" (1989), 32"
× 25.5"; "Childhood
Memories" (1974), 50.5" ×
38"; "Growing Specimen"
(1975), 17" × 12.5".
Courtesy of Pucker Gallery.
Copyright © by Pucker
Gallery.

Samuel Bak. "Flight Experiment." 27 5/8" × 19 3/4"; oil on canvas. Courtesy of Pucker Gallery. Copyright © by Pucker Gallery.

Samuel Bak. "Padres" (1992). 38 9/16" × 51 3/16"; oil on linen. Courtesy of Pucker Gallery. Copyright © by Pucker Gallery.

Samuel Bak. "Group Portrait with a Blue Angel." 52.5" × 39.25"; oil on linen.
Courtesy of Pucker Gallery. Copyright © by Pucker Gallery.

Samuel Bak. "Wall." 25 5/8" × 31 15/16 "; oil on linen. Courtesy of Pucker Gallery. Copyright © by Pucker Gallery.

Samuel Bak. "Small Landscape" (1973). 8.5" × 11"; oil on linen. Courtesy of Pucker Gallery. Copyright © by Pucker Gallery.

Arie A. Galles

"Fourteen Stations"

According to Arie A. Galles, "Under no condition can art express the Holocaust. To prohibit art from confronting this horror, however, is to assign victory to its perpetrators. Every survivor must individually affirm his or her humanity and existence."

Galles's suite of drawings, "Fourteen Stations," is a Kaddish (memorial prayer) for all those who perished in the Nazi con-

centration camps. The suite consists of fifteen 47 ½" by 75" drawings in charcoal and white conté crayon. The drawings are framed in hand-forged wrought-iron frames.

Galles's images are based on aerial photographs of the camps taken by Luftwaffe and Allied Air Force reconnaissance during World War II. Within each drawing is embedded one-fourteenth of the Kaddish divided into the natural breaks in its recitation. The Aramaic and Hebrew phrases are invisible; they are interwoven into the pattern and texture of each drawing of the thirteen stations, the death camps, built on or near railroad lines: the final station for six million Jews and others.

The fourteenth station depicts Babi Yar, the infamous ravine outside Kiev, which was the final stop for tens of thousands of Ukrainian Jews before being shot. The fifteenth station drawing, "Khurbn," presents a view of Camp Belzec taken by the Luftwaffe on May 26, 1940. It is a record of the area before the camp was carved out of the forest and became a death factory.

All the drawings are mounted and numbered from right to left according to the Hebrew alphabet: Auschwitz-Birkenau, Babi Yar, Buchenwald, Belzec, Bergen-Belsen, Gross-Rosen,

Arie A. Galles. © 1994. "Fourteen Stations." Suite: Station #5. Bergen-Belsen. 1994. 47 ½" × 75"; charcoal and white conté on arches, wrought iron frame. Based on an RAF photograph. Photo: Tim Volk.

When Memory Speaks

Dachau, Chelmno, Treblinka, Mauthausen, Maidanek, Sobibor, Ravensbrük, and Stutthof. The full suite completes the Kaddish. The artist states:

> Through visual evidence recorded by their own aerial reconnaissance cameras, the perpetrators of the Holocaust have provided irrefutable confirmation of these extermination camps. This truth is reinforced by the reconnaissance photographs of the Allies. Here is the evidence of the massive industrial scale of the Nazis' "Final Solution to the Jewish Problem." Humanity must remain aware that the Holocaust was a calculated, systematic commitment to the eradication of an entire people. I offer the "Fourteen Stations" as icons for tolerance, compassion, and remembrance.[10]

Arie A. Galles. © 1995. "Fourteen Stations." Suite: Station #2. Babi Yar. 1995. 47 ½" × 75"; charcoal and white conté on arches, wrought iron frame. Based on aerial photographs taken by the Luftwaffe. Photo: Tim Volk.

A professor of fine arts at Fairleigh Dickinson University, Galles was born in 1944 in Tashkent, Uzbekistan. He lived in Poland and Israel before immigrating to the United States.

IV | Living Memorials and Educational Institutions

As THE TWENTIETH CENTURY draws to a close, there is an increasing need to tell the whole story of the Holocaust, which includes recent exposure of serious Swiss Bank blunders. An extensive effort to recover Jewish assets deposited in Swiss banks, which was kept quiet for the past fifty years by Swiss bankers, has been exposed in a moral crusade to track down stolen wealth hidden in the vaults of Zurich banks and restore it to victims of the Holocaust. At the present time, a class action suit to recover the $20 billion deposited and hidden in Swiss banks of dormant accounts is taking place. Besides the Swiss banks, other European banks are also under investigation.

Once the generation of witnesses has passed away, we will have legacy to ponder—a legacy that deniers are attempting to discredit with their claiming that the Holocaust never existed. We who are entrusted with protecting this legacy cannot permit silence and indifference. More importantly, we cannot permit this mosaic of pain, terror, and tragic human events to be erased from our memory. A fundamental question of how one makes art, in such a moment during the Holocaust, is asked. How does one create?

Poets, writers, and postwar artists such as Rico Lebrun, Mauricio Lasansky, Ben Shahn, Audrey Flack, George Segal, and Larry Rivers, together with other painters and sculptors, have responded both realistically and symbolically to the Nazi genocide. Those who personally experienced the Holocaust and those who did not, of course, feel its impact in different ways. Its effect also depends on the age of the individual artists—whether they are younger or older than 40 to 50 years of age—and on the influences of their own background and life experience.

Since there are no historical or metaphysical answers to why millions of people were systematically murdered, without hardly any opposition, the victims' art must serve as our reality, our witness. Invading our consciences through the depiction of enduring deprivation and abuse, often through the smoke of chimneys, this art reflects the inexorable momentum of the European culture's darkest stain.

An Overview of New York:
A Living Memorial to the Holocaust Museum of Jewish Heritage*

David Altshuler

Since its inception, I have served as director of A Living Memorial to the Holocaust Museum of Jewish Heritage, now open to the public on a majestic waterfront site in Battery Park City in Lower Manhattan. As the New York area's principal public institution of Holocaust remembrance, the mission of the Museum is to educate people of all ages and backgrounds about the Holocaust and twentieth-century Jewish history. In the period since the Museum was founded by the New York Holocaust Memorial Commission, I have had occasion to reflect on the meaning and substance of Jewish memory in the face of the Holocaust.

The negotiation of memory and memorialization never has been an easy task, especially when confronted by the Holocaust. The Museum of Jewish Heritage takes a truly unique view of this challenge. As its name suggests, the Museum was established as a living memorial; that is, it seeks not to treat the historical events of the Holocaust as static and finite, but to weave that cataclysmic period into the greater fabric of modern Jewish history and heritage. Therefore, the Museum places the Holocaust within the context of twentieth-century Jewish history through the following three themes:

- *Tradition and Change: Jewish Life in the Early 20th Century* paints a portrait of the vibrant and richly diverse Jewish communities that flourished in Europe and North Africa in the early 20th century.
- *War Against the Jews: The Holocaust* explores the incomparable tragedy of the Holocaust, chiefly as it was experienced by individual Jews who perished, those who resisted, and those who survived.
- *Renewal and Remembrance: Jewish Heritage in the Contemporary World* describes the bittersweet process of the evolution of Jewish heritage in the aftermath of the Holocaust and heralds the founding of the State

*"An Overview of New York" was used by permission of David Altshuler.

of Israel and the development of Jewish life in the United States and throughout the Diaspora.

These themes are illuminated in the Museum's core exhibition through the Museum's collection of historical artifacts, photographs, documents, and film footage. The exhibition further is animated by videotaped testimonies of Holocaust survivors and eyewitnesses, made available through the Museum's own efforts and our special relationship with Steven Spielberg's Survivors of the Shoah Visual History Foundation. These first-hand participants in and observers of this history narrate the exhibition, enriching the visitor's experience and adding layers of meaning to the events examined.

These touchstones of the core exhibition embody the Museum's singularity. The Museum's treatment of the history of the Holocaust and of Jewish life before and after emphasizes individual experience, both the extraordinary and the everyday. It seeks to restore a measure of humanity to the inchoate inhumanity of the Holocaust. The victims and survivors are not remembered as numbers or as ghosts inhabiting a vanished world. Instead, they recalled as people who built a complex and colorful civilization that still is very much alive. It is a civilization that has made and continues to make remarkable achievements culturally, artistically, spiritually,

Architectural Model, Museum of Jewish Heritage—A Living Memorial to the Holocaust. Courtesy of the Museum of Jewish Heritage.

and politically. These occasionally disparate factors conspire to form the backbone of the ideas of heritage. While the story of this heritage is particularly Jewish, its meaning is universal. When this heritage is taken together with the Holocaust, a powerful resonance occurs, which touches on issues of war and genocide, survival and cultural continuity, and the legacy of history itself.

Looking to the Future: Preserving the Past

An extensive body of memoirs, artworks, and diaries available for research can be found in various centers and memorial museums. More colleges, universities, Jewish community centers, and other institutions are establishing Holocaust-resource educational centers and museums throughout the country. For example, the Leo Baeck Institute (named after Rabbi Baeck of Terezin) in New York, and The Yad Vashem Museum in Israel, with its permanent memorial to "the Avenue of the Righteous" dedicated to the Christians who risked their lives to save Jewish people, houses a large collection of Holocaust art, photography, film, documents, diaries, and other written materials. The Yad Vashem is actively involved in education and in teacher training seminars.

Records of the buried diaries of Chaim Kaplan, like many other documents, provide an overwhelming source of information. These islands of horror keep memories alive on paper and represent one of the most important testaments to life.

Escape from heavily guarded camps was extremely difficult, although isolated cases did occur. Those who were fortunate enough to avoid deportation to camps and were able to buy forged baptismal certificates (while successfully posing as Aryans) survived the war together with some who descended to life in the sewers or those who joined the partisans in the forests. Numerous Christian families hid Jews in cellars, on farms, in attics, and in bunkers. Some children were placed in convents; most of them never saw their parents again. In their efforts to shelter their children, many mothers and fathers gave them up to friends or neighbors. The fate of these children after liberation varied.

The Museum of Kibbutz Lochamei Haghettaot was founded by the curator Miriam Novich in fulfillment of a promise Novich made to Yitzak Katzenelson, a poet and underground

resistance leader who perished in Auschwitz, to collect documents on the Holocaust. This Museum focuses on the Resistance in the ghettos and camps. Its holdings consist of an extensive body of art from the Holocaust, which includes a substantial collection of children's art and poetry, paintings, and sculpture depicting the Jewish Resistance.

Many artists continue to respond to the heroic uprising of the Warsaw ghetto which was led by a small group of poorly armed Jewish youths. Most of them perished. Commemoration of this event is handled by the leader of the Jewish Ghetto Fighters, the young Mordecai Anielewicz. The uprising has been memorialized in Natan Rapoport's figurative sculpture located on the Parkway in Philadelphia, a Memorial to the Jewish Martyrs. The sculpture serves as the center for a gathering every April, on the anniversary of the Warsaw ghetto uprising. Among Rapoport's many other monumental sculptures are his statue of Job modeled after a survivor, housed at the Yad Vashem Museum in Israel, and a 15-foot bronze sculpture of an American soldier carrying a concentration camp victim in his arms. A project supported by former Governor Thomas Kean of New Jersey, the American soldier sculpture has appropriately been placed in Liberty State Park in Jersey City, facing the Statue of Liberty.

Although New Jersey was one of the earliest states (together with Ohio) to establish Holocaust education programs, pedagogical efforts began as early as 1973 by individual teachers, college professors, surviving victims, Jewish organizations, and many others in coordination with the Anti-Defamation League. The Holocaust project did not become an official reality until 1981, when Governor Kean issued a Holocaust Council Executive Order.

In 1991, Governor Jim Florio signed legislation under the New Jersey law, established a Commission on the Holocaust Education, and in the Spring of 1994, Governor Christine Todd Whitman signed into law a Holocaust genocide mandate bill, with implementation of training programs for teachers in public schools. During the past twenty-five years Dr. Paul B. Winkler, executive director of the New Jersey Commission on Holocaust Education, has been a most dedicated member and continues to be a vital force in New Jersey's Genocide Education Program.

Raoul Wallenberg and U.S. Holocaust Museums

In 1944, the war was coming to an end, most of Europe's Jews were already dead. Sadly, the world leaders had known about the exterminations in Auschwitz and had done nothing. Pressure was again placed on President Franklin D. Roosevelt and the United States, which all these years had done nothing to prevent the slaughter, even to try to save the last remnants of Jews still left in Hungary. In response to this pressure, the War Refugee Board was established, and neutral Sweden, which continued to maintain relations with Germany, was approached for help. Raoul Wallenberg, a Swedish diplomat,

Richard Serra.
"Gravity" (1991). Cor-Ten Steel. Hall of Witness, Western Terminus. 12' × 12' × 10'; Edward Owen for the USHMM.

Joel Shapiro. "Loss and Regeneration" (1993). Bronze, two parts (figure and house). Figure: 25'9" × 17'8" × 12'9", house: 9' × 7'8" × 7'8". Western Plaza. Edward Owen for the USHMM.

was given authority to create the so-called Safe Homes, by which Swedish neutral passports were issued in order to save the remaining Hungarian Jews from extermination. Recent exposure suggests that the neutral Sweden was financially involved with Germany, thus Wallenberg's position gave him a sense of power and protection. After his arrival in Budapest in the summer of 1944, Wallenberg and his staff set out almost immediately to design and print documents that duplicated the Swedish passports (emblazoned with yellow and blue, the colors of the Swedish national flag). They ultimately saved thousands of people.

After the Russian liberation, the Red Army officials suddenly whisked Wallenberg away, and he was never heard of again. The mystery about his disappearance continues, despite strong government pressures to discover the truth about his fate.

The United States Holocaust Memorial Museum, built on

Raoul Wallenberg Place, preserves the name of the Swedish diplomat who saved Hungarian Jews. Designed in Washington by architect James Ingo Freed, of Pei, Cobb, Freed, and Partners of New York City, the Museum opened in April of 1993, in honor of the date of the Warsaw Uprising. All its efforts are dedicated to educating the world about the history of the Hitler years. Freed, a refugee from Germany, has immersed himself in the books, films, and other materials on the topic.

In his dedication of The Holocaust Memorial Museum on April 22, 1993, President Clinton confirmed the tragedy of the world's indifference to the Jews:

> Before the war even started the door to liberty was shut, and even after the United States and the Allies attacked Germany, rail lines to the camp were left undisturbed.
>
> It is our obligation to remember this nightmare and struggle against all injustice.

The Museum is a three-story atrium of steel, stone, and glass whose design with its narrowing staircase attempts to evoke the destruction of World War II. Among the art are a bronze sculpture by Joel Shapiro called "Loss and Regeneration," which suggests a house turned upside down, and Ellsworth Kelly's white-on-white "Memorial Installation" whose powerful silence speaks to us of the *Shoah*'s horror. Sol LeWitt's "Consequence," a large body adhering to the museum's walls with black and colored squares, and Richard Serra's "Gravity," an imposing slab of steel interior sculpture reflect on the human brutality.

It took fifteen years to make the Museum a reality. At the present time, it holds the largest collection of Holocaust art and research material in any permanent exhibition in the West. The goal of the Museum is to educate and to teach ethical and moral values and to continue to guard against racism and to warn against silence.

Many sophisticated reasons have been given for studying and teaching the Holocaust. The usual reasons point to the future: It must never happen again. But in a way, we kid ourselves, for in an altered version it could happen again. Indeed, allowing for changes in location, magnitude, perpetrators, and victims, it is already happening. We must stand guard and be watchful. Consequently, it is our collective responsibility to learn and to teach about the Holocaust.

"The victims outlived the hatred of the Nazis and their collaborators, 'Al Kiddush Hashem,' sanctifying God. They continue to struggle against racism and injustices," reflects Dr.

Robert Kovacs, a son of surviving concentration camp parents and a dedicated Holocaust educator.

Another museum, the Museum of Tolerance/Simon Wiesenthal Center, was founded in 1977 in Los Angeles and named after the famed Nazi hunter, Simon Wiesenthal. At first it was identified by the public with the pursuit of Nazi war criminals; the focus of the Center and Museum has expanded to larger issues of human rights. The Center has become one of the leading human rights agencies, with concerns ranging from the genocide in Rwanda and Bosnia to the use of cyberspace in neo-Nazi and extremist propaganda. Together with this social action component, educational outreach has been a focus of the Center as well. The Center attempts to bring the lessons of the Holocaust to future generations through the use of the Academy Award-winning documentary *Genocide* and other films created under the Center's film division, Moriah. It also brings Holocaust survivors together with students. A key part of its program was the opening of the Museum of Tolerance on February 8, 1993. This educational museum has been described as a human rights laboratory for the twentieth century, and it has offices in Toronto, Paris, Jerusalem, and Buenos Aires, as well as Los Angeles, New York, and Miami with focus on the past, present, and future. The Museum is devoted to Holocaust studies and general twentieth-century issues of genocide.

The further we look backward, the further forward we will be able to prevent similar catastrophes. We cannot be seduced into betraying humanistic ideals. When innocent lives are endangered and human dignity is seen to be in jeopardy, it is our obligation to take action. No child must be allowed to experience hunger, terror, and murder. As we confront violence and racial hatred in the world, we must not remain silent. Let justice rise out of the ashes of the perished, especially those of the one and a half million children who did not have the chance to grow up, to play, and to laugh.

NOTES

Introduction

1. Primo Levi, *Survival in Auschwitz, The Nazi Assault on Humanity* (New York: Macmillan, 1961).

I

1. From Dr. Burton Wasserman's letter to Nelly Toll. No date.

II

1. Konrad Heiden, *Der Fuehrer—Hitler's Rise to Power* (Boston: Houghton Mifflin Co., 1944), p. 46.
2. Ibid.
3. E. P. Kulawiec, *Janusz Korczak—The Child's Best Friend* (New York: University Press of America, 1979).

III

1. Mauricio Lasansky, *The Nazi Drawings* (Iowa City, Iowa: University of Iowa).
2. Audrey Flack, *Audrey Flack on Painting* (New York: Harry N. Abrams, 1985), p. 78. Excerpts courtesy of Audrey Flack.

Notes

3. Ibid.

4. Ibid.

5. Ibid.

6. Ibid., p. 81.

7. John Ravenal, *Sidney Goodman's Spectacle* (Philadelphia: Philadelphia Museum of Art, November 13, 1995).

8. Samuel Bak, *Fruit of Knowledge* (Boston: Pucker Gallery, 1995), p. 7.

9. Ibid., pp. 7, 13.

10. Arie A. Galles, *The Fourteen Stations* (Arie A. Galles, 1994).

SELECTED BIBLIOGRAPHY

Bak, Samuel. *Chess as a Metaphor in the Art of Samuel Bak.* Montreux, Switzerland: Olsommer, 1991.

Bak, Samuel. *The Fruit of Knowledge.* Boston: Pucker Gallery, 1995.

Bak, Samuel. *The Past Continues.* Boston: David G. Godine, 1988.

Bernbaum, Israel. *My Brother's Keeper: The Holocaust Through the Eyes of an Artist.* New York: Putnam, 1985.

Bierenbaum, John. *The Story of Raoul Wallenberg.* New York: Viking Press, 1981.

Blatter, Janet, and Sybil Milton. *The Art of the Holocaust.* New York: Rutledge Press, 1981.

Davidowicz, Lucy S. *The War Against the Jews 1933–1945.* New York: Holt, Rinehart and Winston, 1975.

Feinstein, Stephen, ed. *Witness and Legacy: Contemporary Art About the Holocaust.* Minneapolis, Minn.: Lerner Publications, 1994.

Flack, Audrey. *Audrey Flack on Painting.* New York: Harry N. Abrams, 1985.

Ghetto Museum. *Terezin.* Terezin: Memorial Terezin.

Gilbert, Barbara (curator). *From Ashes to the Rainbow: A Tribute to Raoul Wallenberg. Works by Alice Lok Cahana.* Los Angeles. Hebrew Union College, Skirball Museum, 1986.

Heiden, Konrad. *Der Fuehrer—Hitler's Rise to Power.* Boston: Houghton Mifflin Co., 1944.

Hilberg, Raul. "Conscience from Burlington." *Hadassah* Magazine, August/September 1991, pp. 21–23.

Hilberg, Raul. *The Destruction of European Jews.* New York: Holmes and Meier, 1985.

Selected Bibliography

"The Holocaust in Contemporary Art." Exhibit at the Holman Hall Art Gallery, March 27–April 15, 1989. Trenton, N.J.: Trenton State College, 1989.

Kantor, Alfred. *The Book of Alfred Kantor.* New York: McGraw-Hill, 1971.

Kitaj, R. B. *First Diaspora Manifesto by R. B. Kitaj.* London: Thames and Hudson, 1989.

Kren, George M., and Leon Rappaport. *The Holocaust and the Crisis of Human Behavior.* New York and London: Holmes and Meien Publishing, 1980.

Kulawiec, E. P. *Janusz Korczak—The Child's Best Friend.* New York: University Press of America, 1979.

Lasansky, Mauricio. *The Nazi Drawings by Mauricio Lasansky.* Iowa City: University of Iowa Press, 1976.

Levi, Primo. *The Drowned and the Saved.* New York: Vintage Books, 1989.

Levi, Primo. *Survival in Auschwitz.* New York: Macmillan Press, 1961.

Lifton, Robert J. *Nazi Doctors: Medical Killing and the Psychology of Genocide.* New York: Basic Books, 1988.

New York Times, December 11, 1986. Wiesel Speech.

Nicholas, Lynn H. *The Rape of Europe.* New York: Alfred A. Knopf, 1944.

Toll, Nelly. *Without Surrender: Art of the Holocaust.* Philadelphia: Running Press, 1978.

INDEX

About the Author

NELLY TOLL teaches Humanities at Rowan University. A frequent lecturer and former guide at the Philadelphia Museum of Art, she is currently pursuing a doctorate degree in Literacy at the University of Pennsylvania. She is author of *Without Surrender: Art of the Holocaust* and *Behind the Secret Window*, which was adapted into a play at the Annenberg Theatre of the University of Pennsylvania in June 1997 and is presently touring Europe.